HOW TO CREATE A
HIGH PROFIT
PHOTOGRAPHY
BUSINESS
IN ANY MARKET

JAMES WILLIAMS

AMHERST MEDIA, INC. ■ BUFFALO, NY

DEDICATION

I'm so blessed that my wife, Cathy, has been in my life for the past thirty-four years. I cannot, in a single paragraph, begin to express the influence she has had on my life. Family has always been and will always be her priority. Our children, Lisa and Jimmy, have the best mother in the world. Her love, guidance, and support never waiver. It is to her, my wife Cathy, that I dedicate this book.

Published by:
Amherst Media®
P.O. Box 586
Buffalo, N.Y. 14226
Fax: 716-874-4508
www.AmherstMedia.com

Publisher: Craig Alesse
Senior Editor/Production Manager: Michelle Perkins
Assistant Editor: Barbara A. Lynch-Johnt

ISBN: 1-58428-182-0
Library of Congress Control Number: 2005937363
Printed in Korea.
10 9 8 7 6 5 4 3 2 1

BK
$31.11

Notice of Disclaimer: The information contained in this book is based on the author's experience and opinions. The author and publisher will not be held liable for the use or misuse of the information in this book.

TABLE OF CONTENTS

ACKNOWLEDGMENTS .6

ABOUT THE AUTHOR .8

1. INTRODUCTION .9

2. BEGIN WITH THE END IN MIND11
Set Short- and Long-Range Goals11
What Kind of Clients Do You Want to Attract?12
 Telephone Skills .12
 Curb Appeal .13
Everything Must Reflect Your Image14
Success Leaves Clues .15

3. MASTER YOUR PHOTOGRAPHY SKILLS17
A Professional Look .18
Studio Lighting .19
 Fill Light .19
 Main Light .20
 Hair Lights and Background Lights25
Outdoor Lighting .29
 Reflectors and Gobos .29
 Flash .30
 Shadowed Eyes .30
Posing .30
 Head-and-Shoulders Poses .30
 Three-Quarter-Length Poses34
 Full-Length Poses .35

Overweight Subjects 35

Lens Selection . 36

Practice, Practice, and More Practice 37

Videos, Books, Magazines, and Seminars 38

Find a Mentor . 39

Be Honest with Yourself 39

4. PSYCHOLOGY OF

A PORTRAIT SESSION 40

Create a Genuine Interest 40

Listen and Ask Questions 44

Personality is Everything 45

A Relaxing, Comfortable Atmosphere 46

5. BUSINESS SKILLS 47

Managing Your Business 47

Manufacturer *and* Retailer 47

Pricing . 48

Surround Yourself with Great Employees

and Suppliers . 53

Employees . 53

Suppliers . 54

Photo Supplies . 55

Run the Business, Don't Let It Run You 55

Cash Flow . 56

Keep the Overhead Low 56

It's All About the Sizzle 58

6. MAKING SALES HAPPEN 59

It Starts in the Camera Room 59

Senior Portraits . 59

Wedding Photography 61

Children . 62

Setting the Mood for Sales 64

Make it Easy for Them

to Get What They Want 69

The Sales Presentation 69

Know When to Close the Sale 69

7. THE TELEPHONE 71

Answering Machine . 71

Etiquette . 71

Sound Like a Real Professional 73

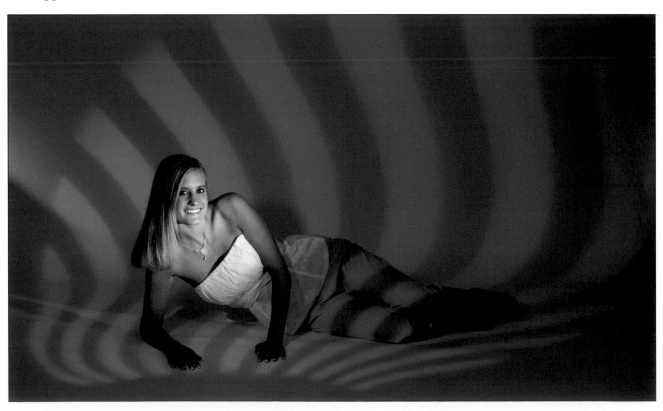

8. DIVERSIFICATION IS SO IMPORTANT 74
High-School Seniors 74
 Keys to Success 74
 Session Fees . 78
 Customer Service at the Session 79
 Proofs Presentation 80
 Placing the Order 81
 Delivering the Order 81
Yearbook Photography 81
 Sports . 82
 Clubs and Organizations 84
 School Dances 85
 One Studio or Several? 88
 Contracts . 89
Sports Leagues . 91
Weddings . 94
 The Type of Client 94
 Telephone Skills 95
 Consultation . 96
 The Wedding Day 97
 After the Wedding Day 100
 Pricing . 101
Families . 101
 Consultations 102
 Basic Goals . 102
 Presentation 102
 Church Directory Companies 102
Products . 103

9. MARKETING IS KEY 104
Basic Marketing Strategies 104
 Plan Ahead . 104
 Spend the Time and Money 105
Direct Mail . 105
 Bulk-Mail Permits 105
 Response Rate 106
 Add a Deadline 106
Mall Displays . 106
Yellow Pages . 107
Word of Mouth 107

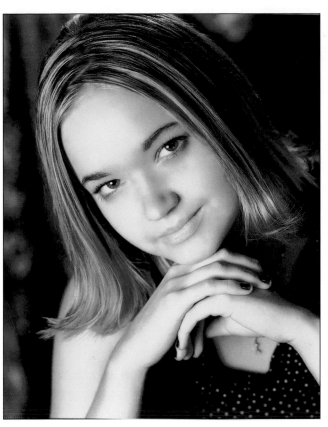

Senior Portraits 107
 Mailing Lists 107
 Mailing Schedule 109
 Twelve-Hour Sale 114
 Discounted Session Fees 114
 High-School Newspapers and Yearbooks . . 114
Wedding Photography 115
Sports League Photography 117
Family Portraiture 118

10. NETWORKING 120

11. SUMMING IT ALL UP 122
Doing Something You Love 122
Good People Skills Are a Must 123
Remember, if it Were Easy,
 Everyone Would Be Doing It 124

Vendors . 125
Index . 126

ACKNOWLEDGMENTS

Ask anyone who is running a successful business of any kind, and they will tell you they could not do it on their own. Surrounding yourself with talented people who share your ideas and vision will definitely make a difference. There have been many people who have contributed to the success of our studio.

First, without my wife's support and organizational skills I would have been out of business a long time ago. She has had a major impact on our success.

There have been and continue to be countless people that I can call on whenever a problem occurs. Over twenty years ago when I first got interested in this business, I enrolled in a photography class at the local vocational school. The instructor at the school was Tom Songer, a very talented Master Photographer who taught me beautiful lighting and posing techniques that I still use today. Unfortunately, Tom died at a very young age from, of all things, a bee sting.

John Shrilla, who used to work for Photogenic and now has his own company, helped me with the layout and lighting I use in my camera room today. Little did I know at that time the value of all this information.

Ladd Scavnicky has helped me with wedding posing, and Ron Kotar has shared his ideas on being more profitable with sports and dance packages and has helped me transition to digital.

Also, I want to thank Patrick Rice, who has help me with print competition, wedding posing, and suggested to Mr. Craig Alesse from Amherst Media that I should write a book for his company. You

are reading that book now. Thank you, Pat, for putting your name and reputation on the line for me.

In addition, I would like to thank Robert Williams from Tallmadge, Ohio for nominating me for membership in the Ohio Society of Professional Photographers. I am both honored and humbled to be a member of the Ohio Society. Thank you, Bob. It's people like you who make the Society what it is: a very select group of some of the finest photographers in the country.

Rex Fee has been a tremendous help to me over the past seven years. I was first introduced to him in February of 1998 when he called us about photographing a five-hundred member soccer league he was president of. He was not your usual parent running a sports league and looking for a photographer; as an advanced amateur photographer himself, he knew just what to look for. In fact, it was his intuitiveness that got us the job—and we have been doing it ever since. We have also been friends since our first meeting. In 1999, I asked Rex to assist me on weddings and, a few years later, asked him to photograph all the game action for the many different high schools we service. He has developed into a first-class wedding and sports-candid shooter. Rex has *never* let me down. When he is given as assignment, I know it will be done professionally. Thank you, Rex, for all your help and assistance over the years. I truly value your friendship.

When I switched to a new color lab in 2000, little did I know that I was not only changing to a superior color lab but was also about to begin a new friendship with someone who would be a coach, business advisor, and above all truly be concerned about the success of my business. Mr. Hal Briggs, the owner of Elyria Color Service, is about the finest business partner you will ever find in the lab business. Hal, I want you to know just how much you have helped our operation over the past six years. Thank you for all your help, Hal.

ABOUT THE AUTHOR

James Williams has been involved with photography for more than twenty years. He photographed his first wedding in 1984. The following year he photographed approximately ten high-school seniors in the basement of his home. In 1986, he photographed almost one hundred seniors, again in the basement, while still continuing to photograph weddings. In 1987, the decision was made to build a studio addition onto his home. Today James and his wife Cathy operate a high-end wedding, family, and high-school senior business, along with sports-league and high-school-senior contracts.

James is certified through the Professional Photographers of America (PPA) as well as the Professional Photographers of Ohio. In 2001, he was inducted into the prestigious Society of Professional Photographers of Ohio. Membership is by invitation only. In 2002, he was elected president of the Society of Northern Ohio Professional Photographers. Based out of Cleveland, this organization has a membership of over seventy-five members. In February of 2004, James earned the Accolade of Photographic Mastery from Wedding and Portrait Photographers International (WPPI). He is one of only eight photographers to hold this degree from his home state of Ohio. In 2005, James completed the requirements for his Craftsman degree from PPA and also completed the requirements for the Accolade of Outstanding Photographic Achievement from WPPI.

Williams lectures several times a year at various photography organizations and presents lighting, posing, and marketing seminars at his studio.

1. INTRODUCTION

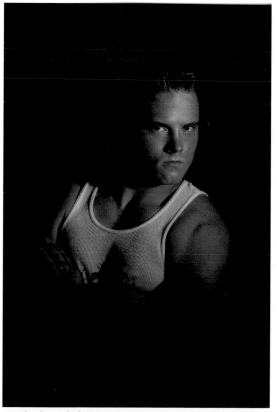

Harsh, direct lighting creates impact. Taking this portrait with a large softbox would not have allowed for the sharp edges and masculine, muscular look.

I think it's fair to say that the photography business is not an easy way to make a living. First of all, anyone can go out and buy a camera, run an ad in the local newspaper, and claim to be a "professional photographer." I asked a Kodak representative what the definition of a professional photographer was. He told me anytime someone is paid to do photography they are considered professional. In the United States, you don't need any kind of license to operate a photography business like you do in some countries. As long as you can create images that customers are willing to pay for, you're in business.

It's sad to say, but the average yearly wage for a professional photographer in this country is approximately $25,000.00, according to the PPA. There are some photographers who don't even make a profit at all and many others depend on their spouse's employment for health-care benefits and additional salary for the household.

In this book, I am going to show you, step-by-step, how you can rise above all the part- and full-time photographers who are struggling in this business. You can earn a very comfortable living as a photographer, but it won't happen by just taking nice pictures, and it's not going to happen overnight.

I'm not going to make any wild claims about being one of the most profitable studios in the country or tell

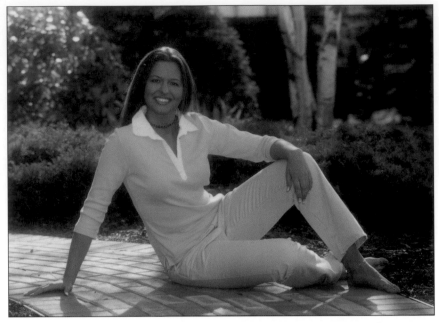

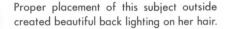

my readers to just learn all my "secrets" and the money will roll in. Exaggerated claims only confuse and mislead. What you are going to get is solid, time-tested information that has worked for us for more than twenty years.

One of the keys to our success has been the diversity of photography that we offer and the level of service we provide. In my opinion, to be successful in the photography business, particularly in a small town, diversification is essential. In the following pages, you will learn what has worked for us, what hasn't, and why. After reading this book, you will be well on your way to operating a successful photography studio in small- or big-town America.

2. BEGIN WITH THE END IN MIND

*W*hat a way to start the beginning of a book, with the end in mind—but this is what you should do. Simply put, starting with the end in mind means visualizing the kind of business you want to have years ahead and making daily decisions to achieve your visualization. Starting with the end in mind is one of many concepts I learned in 1997 at a Stephen R. Covey seminar. For those of you who have never heard of him, Mr. Covey is an extremely successful lecturer and writer. His concepts and ideas are used throughout corporate America. Whether you are running General Motors or a small photography business, certain business principles apply. I highly suggest you read Covey's book, *The Seven Habits of Highly Successful People* (Free Press, 2004).

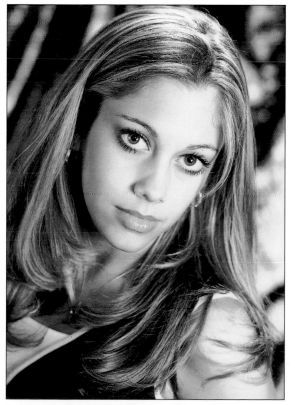

Successful photography isn't just about taking great pictures—it's also about running a profitable business.

◼ SET SHORT- AND LONG-RANGE GOALS

Talk to any business owner and they will tell you how important short- and long-range goals are for the success of your business. Of course, short-range goals will be your daily or weekly goals; your long-range goals are where you want to be in one to five years—or even farther down the line. It's best to have these goals written down; be sure that they are difficult but attainable.

Once you have identified your goals, share your vision with everyone who has anything to do with your

business. The employees you hire will have an impact on whether your goals are achieved. You must surround yourself with successful people—you cannot make it happen by yourself. When I started out in the photography business my short-range goal was to create the best images I possibly could and provide the best-possible service to my clients. One thing is certain: poor service will get you into more trouble with your clients than poor to average photography.

◪ WHAT KIND OF CLIENTS DO YOU WANT TO ATTRACT?

Telephone Skills. The telephone skills—or lack thereof—your employees possess is one of the main factors in determining the type of client you will attract. Great phone skills are simply a must. I would suggest

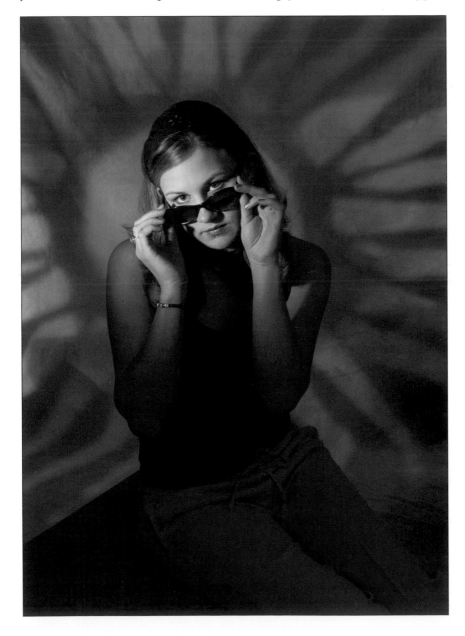

When I started out in the photography business my short-range goal was to create the best images I possibly could and provide the best-possible service to my clients.

A pleasing entranceway to your studio creates an inviting atmosphere. Clients form an opinion of your studio before they set foot in your studio.

that whoever answers the telephone attend a seminar on phone skills. Chapter 7 is dedicated to this very important subject.

Curb Appeal. Let's assume that a client has called and made an appointment to visit your studio to discuss the possibility of you photographing her wedding. What kind of impression does your studio project even before she steps inside? A term used in the real-estate business is "curb appeal." Does your business look good from the street? Is the front door clean and inviting? Is the sidewalk even and attractive, with landscaping and flowers leading to the entrance? Does the door have an expensive feel when you open it? All of these things may sound like silly criteria for someone coming to look at wedding photography, but these perceptions send a message to the client about you and your business.

Do you want to photograph weddings at the local fire hall or at the area country club?

Are you dressed like a five-*hundred* dollar photographer or a five-*thousand* dollar photographer? Do you want to photograph weddings at the local fire hall or at the area country club?

In the photography business, you are dealing (for the most part) with people who are spending discretionary income. They do not *need* pictures. They may want them, but they do not need them. As a result, your studio needs to present an image that makes them *want* to buy. When a client walks in to your studio it should look very clean, inviting, and—of course—very professional. You simply do not have a choice about the environment of your studio if you want to attract clients who have money to spend on photography. A professional-looking studio enhances your overall image and will attract clients with discretionary income.

■ EVERYTHING MUST REFLECT YOUR IMAGE

When I say image is everything, I'm not talking about the images from your camera. I'm talking about the image that is projected to your clients via your telephone, studio décor, your dress, your employees, and every other facet of your business. Price lists, stationary, brochures, and business cards—anything that your clients come in contact with— should reflect a very professional image.

Naturally, your studio should also be clean and well maintained. Although this is just plain common sense, I have visited many studios that were cluttered and dirty. If you do not have the time or desire to

keep your studio clean and professional, hire a cleaning service to come in at least once a week to do it for you. We are very fussy about the interior of our business. After each session, the dressing room carpet is vacuumed, and the mirrors are cleaned. There is simply no excuse for not keeping the interior of your business sparkling clean.

This cumulative effect of this attention to quality and detail will, of course, have a huge impact on the type of clients that are going to patronize you.

■ SUCCESS LEAVES CLUES

Why are some studios successful while others are just barely paying their lab account? Generally speaking, success has little to do with taking "nice pictures." Unfortunately, many photographers think that all they have to do to improve their business is take better pictures. There are others who confuse being busy with being successful; they think that if they are *busy,* they must be *making money.* I don't know about you, but

Paying attention to quality and detail will help attract clients looking for a high-end photographer.

to me, success is measured not by how busy I am, but by how much money I am *keeping* (not just *collecting*).

Seek out the studios in your area that are doing well and compare them with the poorly performing studios. The differences will be extreme. So, just what are the success clues? Well, what is the décor of the studio like? How are the employees dressed? Are the printed materials attractive and well designed? Is the studio clean and well maintained? Some of the clues may take several months to discover, while others will be apparent as soon as you set foot in the studio. If you look carefully, you'll find clues everywhere.

You'll notice that these clues don't have much to do with photography—they are much more fundamental concepts. In fact, most people I see doing well in *this* business would do well in *any* type of business venture—because they simply know what building a successful business requires. Unfortunately, many studio owners do not and, therefore, they don't see the real clues for success.

Only *you* know for sure if you have what it takes to own and operate a photography studio. Many photographers can take beautiful pictures but do a terrible job at marketing, dealing with employees, caring for customers, etc. I truly believe that is why so many studios are not making a decent income—they get into this business because they like to take pictures and give no thought to all of the other elements involved. Remember, just because you love to take photographs does not mean you are cut out to be an owner of a photography studio—but paired with a solid understanding of business, that passion can be a key component of a successful and rewarding career.

3. MASTER YOUR PHOTOGRAPHY SKILLS

*M*astering your photography skills will take at least two years, in my opinion. Basic camera functions can be learned from a variety of photography books and plain old practice. Posing and lighting and interacting with your clients will require more time to master. In this chapter, I will walk you through the skills needed to create beautiful portraits of your subjects while they are enjoying every minute of the process.

Next to marketing and business strategies, photographic skill is the most important subject of this book. Why is photographic tech-

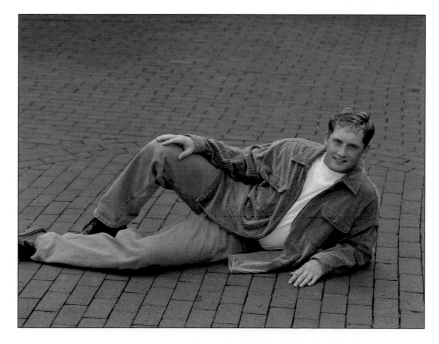

A high camera angle creates a pleasing effect in this image of a high-school senior laying on a brick driveway.

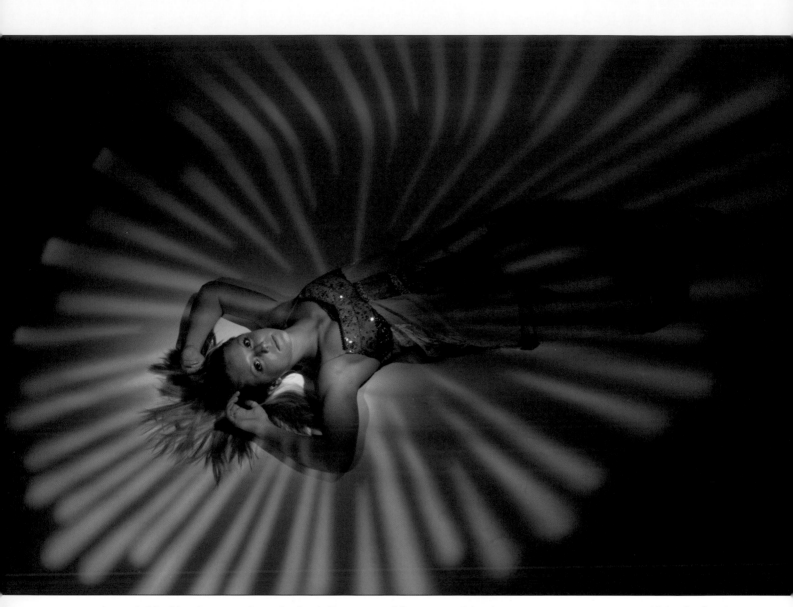

nique *behind* business and marketing? Because without good business practices and strong marketing, there won't be any demand for your photography. You are on your way to operating a successful portrait studio, so, before turning our attention to the business and marketing sections of the book, let's take an in-depth look at beautiful lighting and posing techniques.

ABOVE AND FACING PAGE—High-school seniors are always looking for something different and unique in their images.

◼ A PROFESSIONAL LOOK

What makes a beautiful portrait? Ask several photographers and you will probably get several different answers. Countless books and other learning materials have been devoted to this very subject. I am going to show you what *I* think is important to achieving a professional-looking photograph. Unless you want your photographs to look like they came from a department store, there are certain things that must be done.

To create a professional-looking photograph you must create depth, form, and shape to the face.

◼ STUDIO LIGHTING

The first thing you must completely understand is lighting. To create a professional-looking photograph you must create depth, form, and shape to the face. In other words, we do not want flat lighting on our subjects.

Fill Light. Many photographers use a reflector to bounce light into the shadow side of the face from the main light instead of an overall fill to create the ratio they want. This is okay to do, but if you are photographing several sessions a day, this strategy will slow you down in the camera room. The reflector is one more device that you have to adjust on each pose.

In my camera room, I start with an overall fill light at f/5.6, bouncing two flash heads into a large halo to produce the same type that you

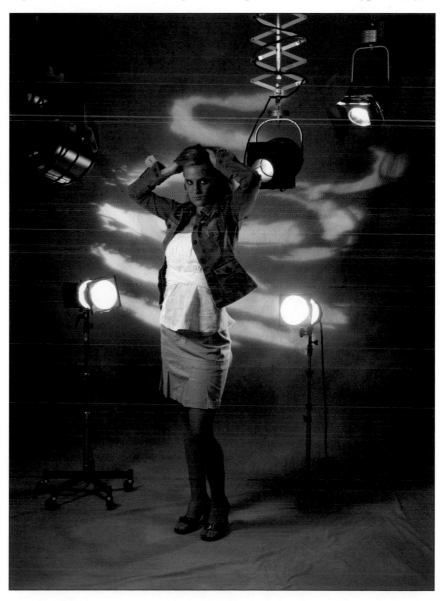

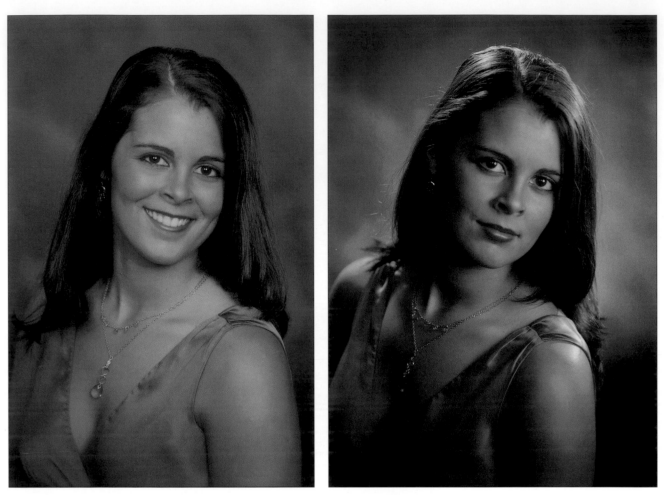

Achieving proper lighting on your subject is essential to getting a great image. The image on the left was created using only fill lights on the subject. This is the type of lighting you will get at a department store. The image on the right has much more impact and is more flattering to the subject. Six lights were used to create this image—two hair lights; one 16-inch parabolic for the face; one background light; and two 36-inch halo lights, which were positioned behind the camera with a power output of f/5.6, creating an overall fill light. Note that the subject has a pleasing ratio of light on her face, her hair is highlighted, and the portrait is vignetted at the bottom.

find outside on a cloudy day—soft, even light all over the subject. If you typically use reflectors for fill in your portraits, give this setup a try— with the fill light behind you at all times, you will definitely pick up speed in your sessions!

Of course, while the fill light is the foundation of good lighting, by itself it is not going to give us the result we want. For that, we need to move on to the main light.

Main Light. The main light creates shadows on the side of the face, and the shadows create depth. The type of light you use as your main light depends on your tastes.

I like to use a 16-inch parabolic light positioned to the left or right of the subject's face. I have tried softboxes and umbrellas, and while they are easier to use and much more forgiving when they are not placed properly, they do produce the crisp light and snap that I like in my pho-

tographs. Also, very few photographers use parabolics, so they give my portraits a different look—and I don't want my pictures looking like my competition's work. By properly placing the parabolic light on the subject, you will be well on your way to creating a beautiful portrait.

The number-one rule in placing the main light is to correctly light the eyes. This is more important than any lighting pattern you can produce on the face. You must have light in the eyes over anything else.

When lighting group portraits, it's important to make sure that each subject's face is lit properly.

The projected light on the background adds dimension to this senior portrait.

Because photography is not an exact science, if you ask several photographers what correct lighting is, you will get several different answers. One thing is for certain: if your definition of correct lighting is using one big fill light behind the camera like they do at all the department stores, you will never be able to charge any more for your work than they do. Why would anyone pay more for *your* images if they look like pictures they can get for 99 cents?

In my opinion, a beautiful portrait will have highlights and shadows on the face, with approximately a 3:1 ratio of light. With your fill lights set at f/5.6 and your main light set at f/8.0 to f/8.5, you will create a pleasing ratio of light on the subject's face. Having a higher ratio of light or total darkness on the shadow side generally does not look as good as being able to see the face on the shadow side. Vignetting the bottom of the portrait and accenting the client's hair and the background with light will add dimension to your work.

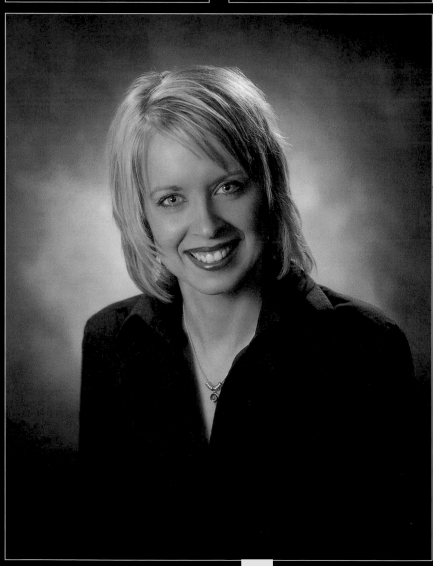

In this series of five photographs, you can see the how increasing the number of lights impacts the portrait. **TOP LEFT**—The first photo illustrates lighting from a large, soft light source metered at f/5.6 at 100 speed, placed high behind the camera position. This lighting is typical of the lighting setup used at a department store. We'll enhance the lighting with each subsequent image. **TOP CENTER**—The second photo utilized a light placed to the right of the subject, metered at approximately f/8.5. When directing the main light onto the subject's face, be sure you have catchlights in the eyes. Aiming the light too high will create dark eye sockets, with no twinkle in the eye. **TOP RIGHT**—In photograph three, a hair light, set at about f/11, was introduced. **BOTTOM LEFT**—The fourth photo shows the effects of adding a kicker (a second hair light), which creates additional highlights in the hair. This second hair light was also set at f/11. Notice that this additional light separated the shoulder from the background. **BOTTOM RIGHT**—In the final image, a background light was added, producing depth in the portrait. Note that the bottom of the portrait is vignetted and fades slightly from view.

Where to direct the light on the subject will, of course, depend on the individual's facial structure, teeth, eyes, hair, and many other factors. The knowledge of how to best light each subject's face is something that will come in time. Be patient and allow yourself plenty of time to master proper lighting. Study the portraits in this book. Look closely at the lighting patterns, and you will be able to determine the direction that the light was coming from.

Here are some basic lighting guidelines. Your subject's eyes are the first thing you want to consider when directing the main light onto the subject's face. First, you must light the eye sockets. This will create sparkle or catchlights in the eyes. The position of the catchlights will be determined by the position of the main light. Be sure the catchlights are not extremely high or low or too far to the left or right. If your subject has deep-seated eye sockets, you are going to have to position the light low to illuminate the eyes. If your subject has more normal eye sockets, you will be able to raise the light up more and may be able to create a triangle of light on the side of the face that's opposite the main light. Remember, the the client's facial structure is the determining factor in placement of the main light. When your subject smiles, look to see what the position of the main light is doing to their teeth. If they have perfect teeth, no problem—but if their teeth are not straight, improper placement of the main light will make them look worse. With your modeling light on, simply look at the teeth when you are moving the light, and you will see if you are creating any kind of nasty shadows.

Hair Lights and Background Lights. Hair lights and background lights are also very important elements—and something I see lacking in many studio portraits. Remember, if your photographs look like those made in a department-store, the client has no reason to pay you more money for your work!

> *Your subject's eyes are the first thing you want to consider when directing the main light.*

PERFECT LIGHTING

It's impossible to prescribe a general lighting strategy that will work for any client, because each subject has unique features. Become familiar with the use of all of the lights in your camera room, as well as the direction of light and the power that works best for each unit.

I strongly recommend you photograph in a dimly lit camera room and use your modeling lights to determine the best placement for each light. Over time, you'll learn to quickly predict how to create perfect lighting for each client. Precision lighting creates beautiful results, but it does take some time to master.

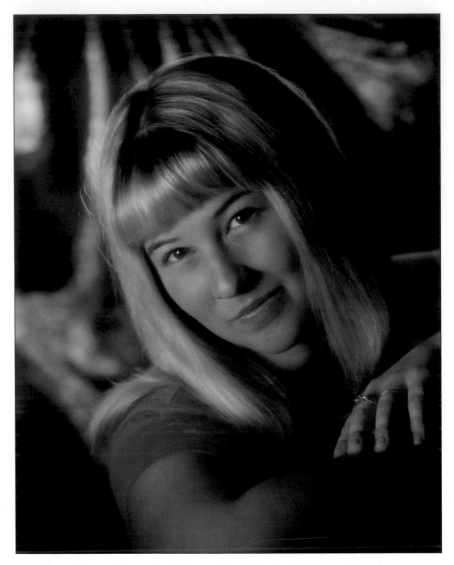

Back lighting the hair is a popular look for female high-school seniors. In this image, an orange gel was used. When creating this type of portrait, be sure that you keep the background light out of camera view.

The color and length of the subject's hair will determine the amount and placement of the hair light. In general, lighter and shorter hair requires less light than darker and longer hair. If your subject has short hair, you will only need enough light on the head to slightly accent the hair and to keep it from blending into the background. Be careful not to have any of the light spill onto the subject's ears or nose. Setting your hair light about a stop or two less than the main light and positioning it approximately 12 inches from their head is a good place to start. Using a hair light with louvers (sometimes called barn doors) on both sides will be a big help in controlling the light.

On subjects with long hair, you are going to need more light. Positioning the light higher will give you broader coverage. I sometimes use two hair lights on a female with long, dark hair. The overhead light is used to illuminate the top of the hair, while a second hair light, placed to the side, will illuminate the length of the hair. For someone with dark

FACING PAGE—A single projection light is all that is being used for this portrait of a beautiful high-school senior. Although the lighting breaks every rule in the book, seniors love lighting with an edge.

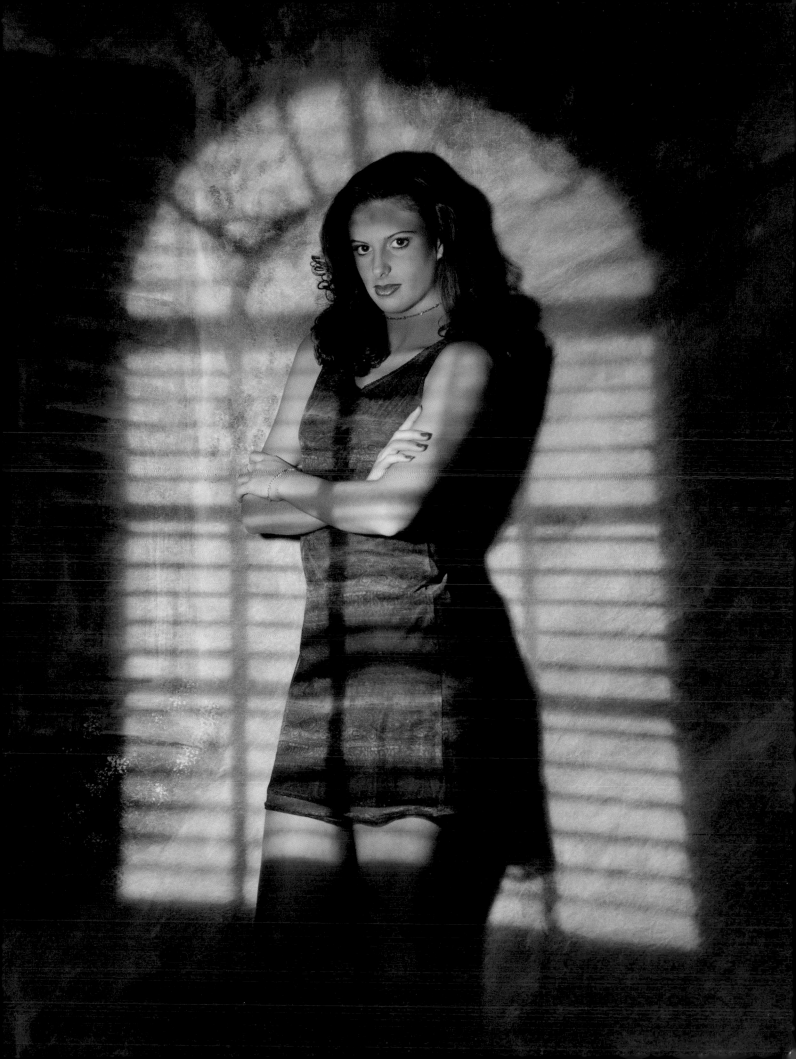

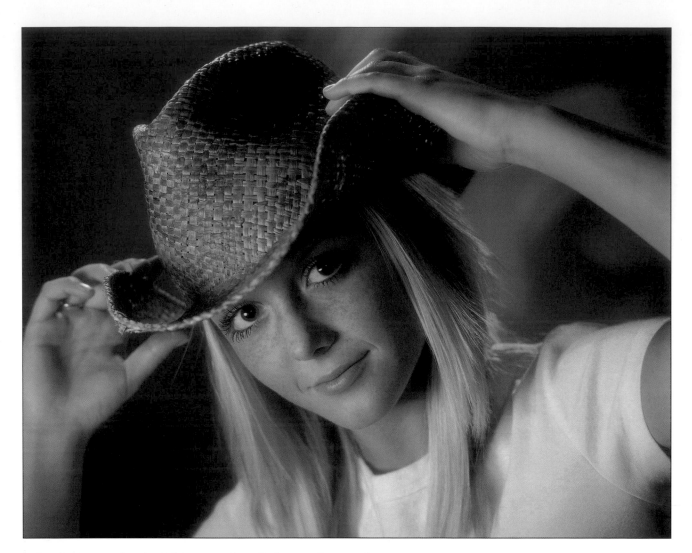

hair, the power level of this secondary light can be equal to or even a stop or two more than the first hair light, depending on the desired effect.

A properly placed background light will give you a nice glow behind your subject. The amount of power from the light and its placement will depend on several factors: the color of background, the length and color of the subject's hair, and whether you are using a gel to create color in the hair. I use Photogenic Studio Master II lights and Photogenic power lights for background effects. Look for units that have very accurate modeling lights so you can determine where the flash is going to go when you fire the camera. Be sure, too, that each of your lights has its own power pack; you want to be able to adjust each of your lights individually, without affecting the power of another light. Just like any other master craftsman, you must have the right tools—and master them—to create beautiful work.

Beautiful lighting with a gorgeous face—what a combination! In this portrait, a high camera angle really accents the subject's eyes. A kicker light from behind accents her hat and hair.

◼ OUTDOOR LIGHTING

Outdoor lighting should be easier to master than indoor photography lighting (where you must correctly place as many as six or eight strobes for each picture). This is not to say that outdoor lighting presents no challenges. Indoors or out, lighting is a skill that takes both time and practice to master. The key element to outdoor light, though, is "seeing" the light—identifying places with good light and placing your subject effectively within those locations. Keep in mind, just like a studio portrait, a good outdoor portrait will have shape and form to the face.

Reflectors and Gobos. The best lighting tools for outdoor portraiture are a reflector and a gobo. Reflectors can be used to open up shadows when the ambient light produces too much contrast or doesn't light the face properly. I personally like to use a 36-inch silver reflector when working outdoors. I've tried gold, but I felt that the skin tones

Just like a studio portrait, a good outdoor portrait will have shape and form to the face.

this type of reflector produced didn't look natural. Of course, the type of reflector you choose should be a matter of personal choice.

Gobos are used to block light from hitting the subject and are good to use in situations were the light is too flat and doesn't reveal the shape and form of the face. Keep in mind that there are many natural gobos in outdoor situations: many times I use fence or trees for this purpose, but a porch can be another good gobo, blocking almost all of the overhead light. If you can find a natural gobo and place your subject in the correct position in relationship to the direction of the light, a supplemental gobo will not be needed.

Flash. Though flash can be used outside, I try to avoid it because of the flat lighting effect it creates. However, there are times when you will have no choice but to employ it. Reflectors are the best way to light a subject outside, but bouncing light into the eyes causes some people to squint, resulting in a very unpleasant expression. In this situation, your only option is to forego the reflector and illuminate their eyes with a little fill flash. Generally I will have the flash set at about half a stop less than the camera aperture setting.

Shadowed Eyes. One of the biggest lighting mistakes I see over and over again is dark eye sockets. This is the result of no light being directed into the eyes. To remedy the problem, use flash or, better yet, a properly placed reflector. You don't want your outdoor subjects to look like raccoons, with dark circles around their eyes.

■ POSING

Posing, like lighting, is something that takes much practice. One of the main elements to good posing is making your subject look natural and relaxed. Try to make the subject appear as if they didn't know you were going to take their picture. One of the best ways to improve your posing is to study the photographs you have taken. Look at every little detail of the pose, and ask yourself what could be improved.

Head-and-Shoulders Poses. Many things can be done to help your subject look better in their photographs. Let's start with a basic head-and-shoulders pose.

If there's one flaw that's common to most head-and-shoulder portraits, it's that the camera angle is too low. Look at a high-school yearbook, and you will see many seniors looking down at the camera. In my opinion, the lens should be several inches above the subject's nose. This will cause your subject to look up at the lens, creating a very pleasing effect. Their eyes will look more attractive, and the camera angle will

Keep in mind that there are many natural gobos in outdoor situations . . .

FACING PAGE—A good pose is one that appears natural and makes the client look relaxed.

even thin out their face slightly. I use a small step stool in my camera room to get to the correct height for my photography.

Also, you should always have your subject at an angle to the camera for a head-and-shoulders pose. If the subject is sitting on the posing stool with his body angled to the right, then his head should be turned in the opposite direction, looking back toward the camera (and vice versa). By turning the head and shoulders in different directions, a more dynamic image is produced.

Another reason why you should strive to differ the head and shoulder angles in relation to the camera is that photographing someone straight-on to the camera for a head-and-shoulders pose will make them look broader. If you want to see what someone looks like in a straight-on pose, look at your driver's license. That pretty much says it all. If your subject is very small—let's say a high-school senior girl who weighs about 95 pounds—you might get away with photographing her a little straight-on to the camera. For everyone else, posing at a slight angle to the camera is best. The bigger the person, the more you should turn them away from the camera.

ABOVE AND FACING PAGE—Black & white photography is popular with high-school seniors. A high camera angle helps to accent the subject's eyes.

Three-Quarter-Length Poses. These poses are done with the subject standing and are cropped approximately at the knee. Again, you want the subject positioned at an angle to the camera. Placement of the hands is important in this type of pose. Having the clients' thumbs anchored in pants pockets, on their hips, or on a prop works well. Be sure not to crop hands or arms out of the image. I would not recommend a three-quarter-length pose for anyone who is overweight.

Some Photoshop work made this three-quarter-length portrait look like a painting.

Props can serve as a posing aid and help to personalize the student's image. Buy a few carefully selected props and encourage students to bring their own to the session.

Remember, your clients want to look their best, so choose poses that flatter them.

Full-Length Poses. The rules that apply to three-quarter poses also apply to full-length shots. If a high-school senior brings in a lot of props for band, sports, dance, etc., then a full-length pose works well. Full-length poses make the subject's head appear small, particularly on wallet-size photographs.

Overweight Subjects. People who are overweight need a lot of help when being posed. Most anyone can pose a thin, beautiful model, but posing someone who is overweight is much more challenging. I remember years ago, an instructor at a seminar I was attending taught me what he called the "H and H" method for posing someone overweight. "H and H" stands for "Hunt for something to Hide behind." In other words, have your subject peek around a panel, tree, or anything that can help hide their weight. Keep your camera angles high as well.

A leopard pattern projected onto this high-school senior created a unique look. A white spotlight was used to ensure that the pattern did not appear on her face.

Never have someone who is overweight sitting in a chair; this will not produce a flattering image.

I'm truly amazed sometimes at the photographs made by "professionals." Nothing has been done to enhance the appearance of the person sitting in front of the camera. In fact, many times the photographer has made the subject look worse! With a lot of practice and time, you can master the art of posing just about anyone. Study in great detail your photographs, and compare them to images by those who constantly make their subjects look great.

◘ LENS SELECTION

Choosing the correct lens is very important when you are striving to create beautiful portraiture. When photographing people, use the longest lens you can. This will flatter your subject's facial features and blur the background, making your subject stand out in the photograph. Your outdoor pictures in particular will look better when the background is out of focus. Keep in mind that, while the shallow depth of field blurs the background, it also makes proper focus even more critical.

With high-school seniors, it is sometimes fun to break the rules and use a short lens to distort a basketball, football, band instrument, etc., that you have them hold out in front of them. You can create some pretty cool effects using this approach.

Using a fisheye lens can create unique images at weddings. Using a lens that the average consumer is not going to have will help ensure that

your photographs look different from the ones that Uncle Harry is snapping at a wedding reception.

◼ PRACTICE, PRACTICE, AND MORE PRACTICE

How do you get to Carnegie Hall? Practice, man, practice! I'm sure most of us have heard that joke. How did I learn how to take beautiful portraits? You guessed it: practice, practice, and more practice. Unless you are truly gifted in posing and lighting, there's just no way around it. I think playing the piano is a good analogy. You can learn all of the notes fairly quickly, but learning to play beautifully will take considerably more time. Photography is the same way; the more you do it, the better you will become.

Learn good posing and lighting from successful photographers in the business and practice what you see in their photographs. Study work

I have been taking pictures professionally for over twenty years, and I still study each and every photograph I take to evaluate my lighting and posing.

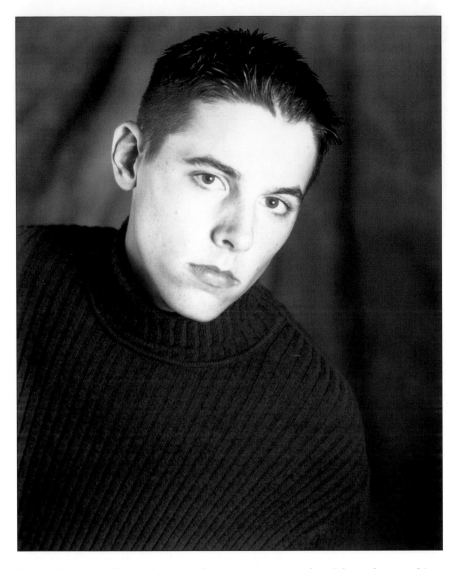

from photographers who are where you want to be. I have been taking pictures professionally for over twenty years, and I still study each and every photograph I take to evaluate my lighting and posing. Being good at posing and lighting is a journey, not a destination.

◼ VIDEOS, BOOKS, MAGAZINES, AND SEMINARS

Much of what I have learned over the past twenty years has been through videos/DVDs, books, magazines, and seminars. Amherst Media, the publisher of this book, publishes many, many fine books on all aspects of photography (see the back of this book for a partial listing). Attending seminars is another great way to learn and to network with others. I would also highly recommend joining state and national photography organizations. Nothing will help you more than all of the networking you can do within these organizations. You can't live long enough to learn all of the marketing, business, and photography skills

by yourself, so take advantage of the lessons others have learned and are willing to share. Of course, you need to exercise good judgment; not all photographers are as successful as they would have you believe.

FIND A MENTOR

In every profession, finding a mentor is essential to learning your new occupation. My daughter recently graduated from college and is now teaching eighth grade. In addition to all of her coursework, she spent several quarters of her college time working in the classroom with different teachers and school systems. This was part of the curriculum to be a teacher. Just about every profession I can think of requires some kind of mentoring. Find someone who operates a successful studio and offer to work for free just so you can learn. Choose someone who has excellent business skills. Remember, wonderful photography without superior business and marketing skills is a recipe for failure. It may be necessary to find a mentor with excellent photography skills and someone else who is operating a successful business.

BE HONEST WITH YOURSELF

Do you really have what it takes to become successful in this business? The photography business is quite different from many other businesses. You are not just buying something wholesale then selling it retail, you're creating the product, marketing your work, and selling it. Do you have support from your family? Do you have the drive, compassion, and desire to take all of the lumps and bumps to be truly successful? Have you been successful at other things in your life? Do you have the right personality for this very people-orientated business? Are you willing to take risks? You must be absolutely honest with yourself. These are just some of the difficult questions you must ask yourself before even considering opening a full time photography operation.

Find someone who operates a successful studio and offer to work for free just so you can learn.

4. PSYCHOLOGY OF A PHOTOGRAPHY SESSION

◼ CREATE A GENUINE INTEREST

Creating a genuine interest in your client when they come in for a photography session can pay big dividends when it comes time for them to place their order.

At our studio, we try to pamper the client as soon as they pull into the parking area. If it is raining when they arrive, someone will greet them outside with a large umbrella and escort them to the door. Of course, we also help them carry any items they may have brought for their session.

As the client approaches the door, the first thing they notice is their name on a marquee near the entrance welcoming them to our

Signs in and around your studio should be attractively designed, well constructed, and regularly maintained.

Special touches like these personalized signs will help build excitement and reinforce the idea that the client has made a wise decision in choosing your studio.

studio. The door they open to enter the studio is beautiful: it has a very rich look and feel to it. Remember, we want everything to be upscale from the moment a client enters the building. Clients are forming an impression of the studio before they are even inside. I have visited studios with a door that is dirty, squeaky, and covered with old photography-association stickers. I've been at some studios where you had to jiggle the doorknob just right to get into the place!

Once we have the client inside, we guide them to our dressing room. On the exterior of the dressing room door is a small framed sign with a miniature spotlight shining onto it that says, "This dressing room reserved for (client's name)." Once again, we are creating excitement before we have started the session.

Inside the dressing room, the client finds two mirrors mounted on the walls, a full-length mirror on the door, a bench built into one of the corners, clothing hooks, a clock mounted on the wall, and an electrical outlet for curling irons, hot curlers, etc.

Once the client has everything situated in the dressing room, I review the clothing and props that they have brought in and ask them if there is a certain pose, prop, etc. that they would like. Some clients will request a certain pose or prop, but most clients leave everything up to me.

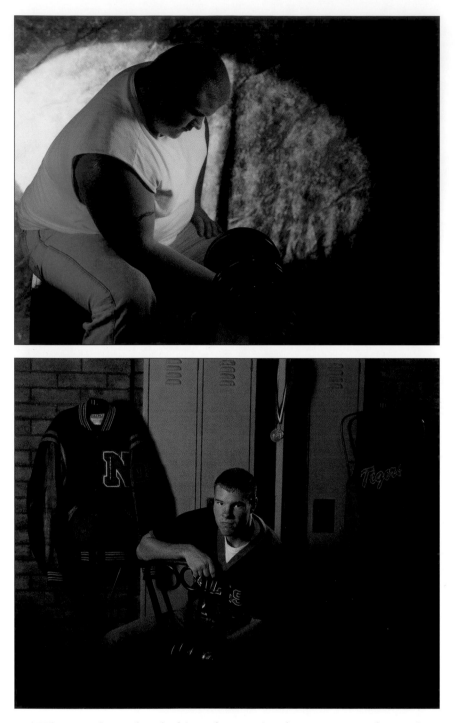

High-school seniors like to bring their own props to the session. They love the variety this adds to their session photos, and the props help them express their unique personalities.

When we have the clothing changes in place, we start the session. You must remember that this is the first time the client will see the camera room. I always shoot in the camera room with the room lights low so that I can see what the modeling lights are doing to the subject. This also creates very nice mood lighting for the subject. It really makes the person feel special.

From the moment I have the client sit on the posing stool, I explain what I am doing and why I am doing it. It is very important for the sub-

Make sure that your camera room is as neat and organized as the other public rooms of your studio.

This senior brought her own roses to the shoot. The selective color in the portrait helped make the sale.

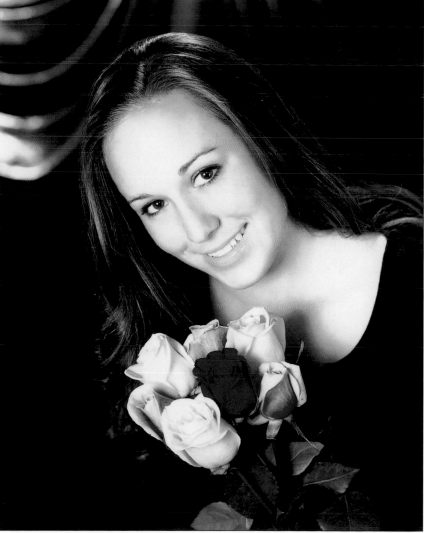

This photograph started out simply as a fairly standard portrait of a senior standing next to a wall. With the application of some Photoshop actions, it has turned into a very unique portrait.

ject to know exactly when you are going to take the photograph. Nothing is worse than sitting on the posing stool with no idea what the photographer is doing or when the camera will be fired.

◼ LISTEN AND ASK QUESTIONS

Constant conversation with your client is essential for good expressions, so find out what your client's interests are and talk about them. (I photograph a lot of high-school seniors, and I have heard some amazing stories over the years!) As you converse, you'll be getting your subject engaged and relaxed—something that will come through in the expressions you achieve in your portraits. And remember, if the client leaves the session liking you, there is a great chance that they are going to like the pictures you took of them, so you are actually setting the stage for your portrait order later on.

■ PERSONALITY IS EVERYTHING

It's difficult to teach you personality from a book. The hard facts are that people who have wonderful personalities are probably going to succeed at just about anything. Before I got into photography, I was very fortunate in my career at General Motors to be around some extremely talented managers. With very few exceptions, the people who rose to the top were not only exceptionally bright but had great personalities. They just had the knack for getting people to do their jobs—and to enjoy them, as well. What does this have to do with photography? Plenty! Photographers with great people skills have a much better chance of succeeding. Not only will their clients be happy, but they will have employees who enjoy working for them as well. What a combination for success!

A motion filter was used to create a great effect in this image of a senior perched on her skateboard.

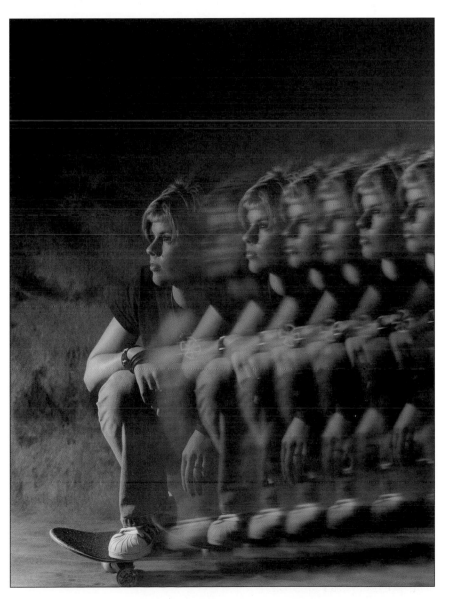

A comfortable seating arrangement is critical when it comes to taking your clients' orders.

■ A RELAXING, COMFORTABLE ATMOSPHERE

Part of the atmosphere in your studio is, of course, going to be created by you and your employees. Keep in mind that you, the studio owner, will set the tone for how your employees interact with the clients. If you are a warm, fuzzy, easygoing person, this will influence your employees. If you are uptight and unpleasant, you will make your employees feel the same way.

Ideally, your studio's overall atmosphere will be relaxing and comfortable. There are many things that can help you achieve this goal. We've already talked about keeping your studio tidy and clean. It should also, however, be well lit and smell good. We have a liquid fragrance we apply to a heat ring placed on one of our lamps that puts out a very pleasant scent that you notice as soon as you walk into the lobby.

Be sure to have comfortable chairs for your customers to sit in when they are placing their orders or waiting to be photographed. (Hopefully nobody is waiting more than a few minutes.) We have cushioned armchairs around a large table for our clients to view and place their orders. You want your clients to be as comfortable as possible during their entire visit. I remember going to a studio and seeing a stand-up counter where the customers stood the whole time placing their photography order! Talk about how *not* to do something! Your furniture does not have to be expensive, but be sure that it's comfortable.

Visit other facilities and take note of the layout, furniture, and the general atmosphere. You will be surprised what you notice when you're really looking.

5. BUSINESS SKILLS

◼ MANAGING YOUR BUSINESS

In my opinion, managing your business is the most important section of this book. As you well know, college degrees at all levels can be earned on the subject of business. Business management is a subject unto itself. All sorts of books, seminars, television programs, and magazines are dedicated to the field of business—it's that big and important a topic. Unfortunately, many of you will still breeze past this section and study posing, lighting, and the camera section of this text! Nevertheless, I will present a focused business approach to running a photography studio.

Manufacturer *and* Retailer. I imagine that most of you got into photography because you like to take beautiful pictures, not because you want to run a business. If you want to make a decent living in the photography business, though, it is imperative that you have skills in marketing and pricing. Running a photography business is very different from many other businesses. The main difference is that you are both a *manufacturer* and a *retailer*. Let me explain.

Walking through a mall, you see all types of stores selling just about anything. In these businesses, the shop owners bought their goods at wholesale prices to sell at marked-up retail prices. Calculated into the price of the goods they are vending is the overhead, employee costs, insurance, rent, and anything else that is needed to run their business. All of these costs must fully be recovered before they even begin to make a profit! Many times the only difference between the products offered in two different stores is the service level that's offered.

> Running a photography business is very different from many other businesses.

Operating a photography business offers all of these challenges *plus* the challenge of manufacturing the product. You are not buying your pictures from a supplier wholesale and selling them retail, you are creating or manufacturing them! As a result, you have many more variables to calculate into the price of your product: cameras, lighting equipment, props, film, flash cards, computers, and all of the other elements that go into creating your product. Don't forget the value of your education— the amount of time and money you have spent learning photography.

Pricing. Given all of these variables, how in the world do you even begin to know what to charge? I'll tell you what most photographers do: they get their hands on a competitor's price list and simply charge a little less. Now *that's* a scientific way to calculate what to charge for your goods and services!

I once asked a photographer who was fairly new in the business how she determined her prices, and she said, "Oh, I just see what the lab charged me and multiply that number by three." If the lab was charging her $3.00 for an 8 x 10-inch print, then she was going to charge the client $9.00 for the picture—so the only cost she was figuring into her calculation was the *lab bill!* What about all of the other costs that went into producing that single print?

Achieving a reasonable profit margin is not an easy task, but there are some basic things that must be considered to ensure profitability.

There are two types of expenses in your business: fixed and variable. Fixed expenses are the same every month, regardless of your volume.

Costs such as rent, insurance, basic phone service, and electricity are examples of fixed costs. Variable costs are associated with the amount of business you are actually doing. Things such as lab bills, wear and tear on equipment, the number of employees needed, frames, and photo mounts are all items that go into the variable cost column.

Offering several different products in your studio is a good idea, but not every product will provide the same level of profitability. For example, if you photograph a one-hundred-member little league team and average $25.00 per player, your gross is about $2500.00. From this $2500.00 gross you must subtract all your costs to deliver the final product. The lab bill will be five- to seven-hundred dollars, the photo mounts will be about one-hundred dollars, your labor costs to assemble the job will be approximately one-hundred dollars, and don't forget some leagues want a kickback (let's assume $250.00)! As you can see

This edgy image allowed the senior to show off his tattoo. The high contrast, mottled background, and dramatic shadow work well in black & white.

from this example, you have reduced your gross of $2500.00 to perhaps only $1350.00. Also, a portion of the "profits" from this job will go toward the cost of phones, rent, utilities, insurances, and your salary. Compare this baseball job to photographing four high-school senior sessions in your studio. If you average $625.00 per senior, you will have grossed about the same amount of money but have a much smaller lab bill, no kickbacks, and only a fraction of the cost for photo mounts. Your fixed costs, rent, utilities, insurances etc., remain the same for the job, although your variable costs will be much lower. Your lab bill for four seniors—including the proofing and processing of the final product—will be much lower than the baseball job. Here's a breakdown of each job.

VARIABLE COSTS TO PHOTOGRAPH ONE-HUNDRED LITTLE LEAGUE PLAYERS:

1. No film or processing cost
2. Lab bill to print packages—$700.00
3. Photo mounts—$100.00
4. Kickback to league—$250.00
5. Labor to assemble packets—$100.00

Total: $1350.00

Note that almost half of the profit (48 percent) is gone before any of your fixed costs are factored in.

VARIABLE COSTS TO PHOTOGRAPH FOUR HIGH-SCHOOL SENIORS:

1. No film or processing costs
2. Lab bill for four seniors—$400.00
3. Photo mounts for four senior packages—$40.00
4. Labor to assemble packages—$30.00
5. Kickback to seniors—$00.00

Total: $470.00

Only about 19 percent, compared to 48 percent for the baseball job, is needed to produce the final product for four seniors. Remember, the fixed costs of your operation must be added into the above totals to get a more accurate figure of your *total* cost of producing the final product.

Fixed costs for running a studio stay the same regardless of your volume. Rent, utilities, labor, office and camera equipment, insurances, ad-

> You will have grossed about the same amount but have a much smaller lab bill.

vertising, studio props, donations, professional dues and fees, bank and credit card fees are all fixed costs. (Bank, credit card fees, and labor costs should vary depending on volume.)

As you can see from the examples above, different product lines will produce different levels of profitability. You may find that there are some types of photography that simply are not worth offering. For the most part, the work done in your studio should focus on your most profitable products. The exception is with jobs like school dances, which aren't nearly as profitable per client but can be worthwhile based on the sheer volume of the work. The prices you are charging, your volume, and your fixed costs will have an impact on the percentages you are keeping from your gross sales. Getting caught with high overhead and excessive labor costs will quickly lead to trouble. Keep your eyes on your costs at all times.

Photographing seniors can be quite profitable. Be sure to charge enough for your high-quality portraiture, and make sure that you offer clients something they can't get at their local department store: good lighting. Here, the student has a 3:1 lighting ratio on his face. A properly positioned background light that adds depth to the image and a hair light adds highlight to the hair. The client's great expression is the perfect finishing touch.

So, given all we have just discussed, just what percentage of your gross should you be keeping? In my opinion, it should be in the 30- to 40-percent range. Anything over 40 percent means you have your operational costs well under control and are charging the prices you should. If you are keeping less than 30 percent of your gross, you have a profit leak somewhere—maybe prices are not where they should be, your overhead is too high, you have too many employees, or there's just not enough business.

If a lack of business is the issue, think long and hard before being tempted to lower your prices—this is a dangerous road to go down to acquire clients. If not enough clients are calling for appointments, there is generally another problem that you need to investigate. Are you offering high-quality portraiture, or do your pictures look like something your clients can get at a department store? Have you spent at least 10 percent of your yearly gross on high-quality mailings and other forms of advertising? This is not easy stuff! Just remember one thing: if you charge big bucks for your photography, you must have a studio that seems worthy of this price.

ABOVE AND FACING PAGE—Be sure to find a lab that can print all of your images to your liking—from the studio to the playing field.

■ SURROUND YOURSELF WITH
GREAT EMPLOYEES AND SUPPLIERS

Employees. Anyone who runs a successful company of any size will tell you the main reason for their success is the people they have working for them. Dedicated employees paired with good leadership is a winning combination for a great organization. The smaller the company, the more important this is. If you have a staff of just three people and one of them is not pulling their weight, you are only running at two-thirds your potential efficiency!

Finding an excellent employee can be difficult at best. I'm not a big fan of running an ad in the newspaper to find someone. In my opinion, the best route to finding good employees is via former clients. We have had a fairly good success rate hiring a client whom we thought would

Dedicated employees paired with good leadership is a winning combination.

There are many issues to consider when deciding who is going to be printing your work—quality, delivery times, prices, and more.

work well in our studio. You may also consider hiring someone part time and offering them a full-time position if they work out well. Many large corporations today hire a person as a contract employee and later hire them full time if they fit in well. Hiring a family member or a friend usually does not work out in the long term. I'm sure there are exceptions, but most of the time it simply causes problems.

When you find someone who is really performing, pay them well. Good employees are hard to find— particularly in the photography business. In a small studio operation, an employee needs to be excellent on the telephone, a good salesperson, organized, have some computer skills, a professional appearance, be pleasant all the time, and, of course, have superb people skills. If you can find someone who can do all this, you have real winner!

Suppliers. In addition to having a great employee or employees to help run your operation, you also need some great suppliers.

Your biggest supplier, of course, will be your photo finisher. Choosing a good lab is not easy. There are many issues to consider when deciding who is going to be printing all of your work. Some things to consider are quality, delivery times, prices, and customer service.

Try to find a lab that is well suited to your type of photography. Because we do so many types of photography, we need a lab that can print dances, sports jobs, high-school seniors, and wedding photography. Some studios choose to send different types of jobs to different

labs. Personally, I find it much easier to send all of our work to one lab. You may spend a little more, but I find it less aggravating dealing with one lab rather than two or three.

When you find a good lab, stay with them. We have been in business over twenty years and have used only two labs. Our first lab serviced us for over fifteen years. The reason we switched was quite simple: when our previous lab started to grow and add to their facilities and employee roster, the quality of the work began to suffer. They were doing a very poor job of managing their growth. A good lab is like a good marriage: you both must have the same goals and standards.

Currently, our lab is Elyria Color Service located in Elyria, Ohio. It is a small lab compared to some others, but their service and quality is simply outstanding! Probably the single best word to describe them would be *consistent*. Job after job, print after print, the photographs are all beautifully printed. They are probably a little higher priced than some of the "mega" labs, but they are certainly well worth it.

That raises an important issue: pricing. While it might be tempting to hunt for a bargain, choosing a lab on price alone would be like a bride only considering pricing when choosing a wedding photographer—and we all know *that's* not a good idea! Find a lab that truly has your success in mind. Work with your lab all the time to make the relationship better. You both will profit as you work together.

In summary, find a lab that is an extension of your goals and quality standards. Be honest with them at all times, and if they are giving you great service and prints, be sure to always pay your lab bill on time.

Photo Supplies. Other suppliers will provide your frames and photo mounts, wedding albums, etc. Again, I find it much easier to deal with one supplier for most of our after-photography needs. Albums, Inc., in Strongsville, Ohio, is our major supplier. After dealing with many other companies over the years, I feel their service cannot be beat. We have been assigned a customer representative at Albums, Inc., so we deal with the same person every time we call. This makes things go so much more smoothly at the studio. Again, it all boils down to customer service and quality products.

■ RUN THE BUSINESS, DON'T LET IT RUN YOU

Many photographers I know—not all, but most of them—try to do most of the work in the studio themselves, under the illusion that it saves them money. Truth be known, there are probably a lot of studio owners who are not even making minimum wage when you factor in all

> Find a lab that is an extension of your goals and quality standards.

of the hours they work. I once heard a speaker at a photography convention say, "Don't spend your time doing $6.00-an-hour work at your studio." He was right; you should spend your time working on your next promotional piece or making long-range marketing plans, not packaging a small job that you could be paying an employee to handle.

Don't get caught in the trap of long hours and no help. You will just burn yourself out, and your business will definitely be negatively impacted. It is extremely difficult to be creative if you are always under stress.

Operate your studio with normal business hours. We are open Monday through Friday from 10:00 a.m. to 5:30 p.m. We are closed on Saturdays and Sundays. Although we have elected not to, I would recommend being open one evening a week until 8:00 p.m., and possibly on Saturdays until 2:00 p.m. If you want to close on a weekday, close on Friday, not Monday. You will get a lot more calls and business on a Monday than a Friday.

■ CASH FLOW

Without question, the single biggest reason businesses of any kind fail is a lack of positive cash flow. Without cash, you will not be able to operate your business, period. Cash is the number-one ingredient for the success of your business. Do whatever is necessary to be certain that you will have access to cash whenever you need it.

If you are just starting out in this business, it would be wise to start out small—probably out of your house, photographing weddings, sports jobs, or any type of assignment that does not require a studio. Buy the best equipment you can afford so that, if and when you do move into a storefront, you'll have a lot of the equipment you'll need. Starting small will give you a chance to see if you are capable of properly managing your cash flow. As you progress, you should be accumulating cash for future purchases and the expansion of your business.

If you do not like managing the business side of your studio, find someone who is experienced at small-business startups, and ask for their advice. Remember, without a good, solid business- and marketing plan, you're headed for trouble.

If you are just starting out in this business, it would be wise to start out small.

■ KEEP THE OVERHEAD LOW

Bigger is not always better. Several years ago, my wife and I looked at a building that was for sale on a main state route in our community. It had approximately 4500 square feet and was only about twenty years old. The price was right, and the location was great.

By the time they are seniors, many high-school students have their driver's license. When you photograph a senior with their car, you can be sure to make the sale.

After the excitement of occupying a new building passed, though, I started thinking about how much more business we would have to do just to make the *same* profit we were making in our small, 1000- square-foot studio. To justify this additional space, we would have to hire another photographer, do more volume, and add additional support staff—just to perhaps make a *little* more income. We could have increased our gross sales by over $100,000.00 and netted *less* profit!

How many businesses, of any kind, have we all seen expand too much and too fast, only to be bankrupt in a few years? If you are in the wonderful position of needing more room because your business is growing, control your volume with price. You can make more money and work less! Do not confuse gross income with profit. Keeping 35 percent of $300,000.00 ($105,000.00) is certainly better than keeping 20 percent of $500,000.00 ($100,000.00). Just think how much more work and help you would need to produce that additional $200,000.00—all for just a $5000.00 return! So, keep the overhead low. High rent will eat away at your profits. If you can afford it, purchase a building; over time, you will build equity and have an additional nest egg for retirement.

Here, we have a nice, relaxed pose, a complementary background, and a great expression—a perfect combination.

◼ ITS ALL ABOUT THE SIZZLE

Making your clients feel special is a very important factor in running your photography business. Having lots of sizzle in your operation will set you apart from your competition.

Just what is meant by "sizzle"? In a fine restaurant, a hostess will take you to your table and probably even place the napkin on your lap. When you receive your dinner, it is on fine china with a beautiful presentation—everything is placed just perfectly on the dinner plate. During your meal, your glass will be kept full, and the waiter will ask several times if there is anything further they can do for you. Now, you *could* have gone to a much less fancy restaurant and gotten a meal for much less money, but you chose a fine dining experience instead. So, why do people frequent restaurants that charge so much more? They want to experience the sizzle!

In the restaurant, the sizzle is the service, the presentation of the food, and the general atmosphere of the dining experience. In your studio, sizzle starts with how the phone is answered, the décor, the cleanliness of the interior and exterior of your studio, and how you dress—simply put, it's the overall impression clients get when they walk into your studio. Without the sizzle, you will never be able to charge higher prices. To *be* expensive, you must *look* expensive.

It is all of the details that add up to a first-class operation that will set you apart from everyone else. There must be compelling reasons for the client to choose you over someone else. So, keep your eye on all of the little things, and help your studio rise above the competition.

6. MAKING SALES HAPPEN

▣ IT STARTS IN THE CAMERA ROOM

A good sales presentation has many important elements, none of which are trickery or high pressure. A good sales presentation starts in the camera room. It means finding out what the client wants and helping them get it. If a client leaves their photo session excited, chances are much better they will be excited when they come in to view and purchase their portraits.

Senior Portraits. During the summer months, we photograph a large number of high-school seniors. Most of the time, one of the parents (usually the mother) comes with the senior for their session. We always invite her into the camera room during her child's session.

Coordinating the background with the subject's clothing adds instant appeal to any photograph.

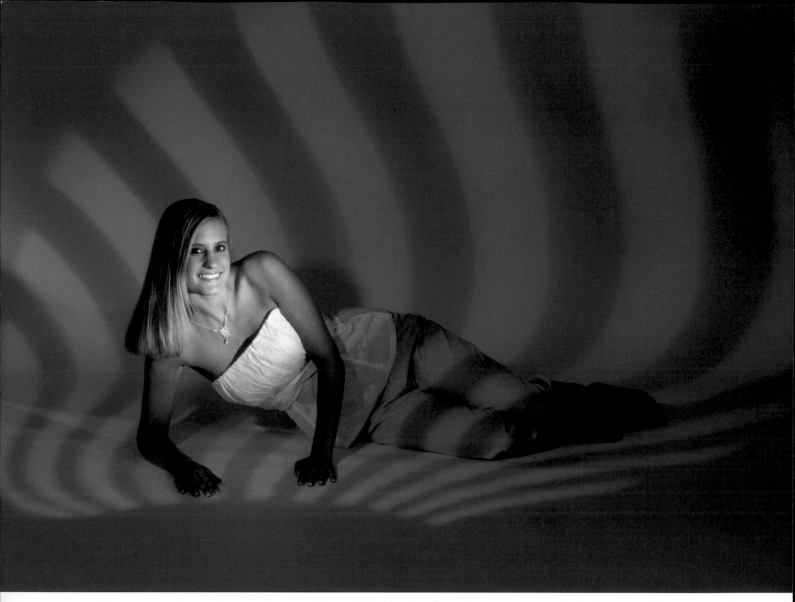

Many moms have told me that an elder child was photographed else-where, and that the photographer didn't allow parents in the camera room. Talk about bad public relations!

Occasionally, a mother does not want to be in the camera room during the session, but that is her choice, not ours. And, yes, I sometimes have a mother who thinks she is a photographer, but I just deal with it rather than chance upsetting her. If the "photographer mom" wants something I know is not going to work on her child, I do it anyway and then go on to what will look correct. She never knows the difference.

By having both mom and the student in the camera room, you can create excitement and start the sales process. We have a nice, large, comfortable chair for Mom to sit in during the session. Many times, she will get out of the chair and get involved in the session. Sometimes, I have her look through the viewfinder to see the photograph; this really helps get her excited. This is a good time to start a conversation concerning what size wall portrait they may want and where in the home it will be

Having both mom and the student in the camera room creates excitement and starts the sales process.

displayed. Again, we are selling the pictures before the clients have even seen them. If the senior and mother had a great experience during the photography session, the stage is set for the ordering phase of the process.

Wedding Photography. Getting bridal couples into the studio for a session several months before the wedding gives you a chance to get to know one another before the big day—something that is positive for both you and the couple. When the wedding day finally comes, they both know your shooting style and know how you will communicate with them during the various photo sessions throughout the day. When photographing the couple in the studio, talk about their big day and start creating excitement about how good they are going to look in their photographs. Many times, the couple will purchase a wall portrait of their studio session to display at the wedding reception. Generally,

Creating pre-wedding bridal portraits in the studio gives you the opportunity to work with the bride before the wedding day and allows your client to become familiar with the way you work. Such a session is mutually beneficial.

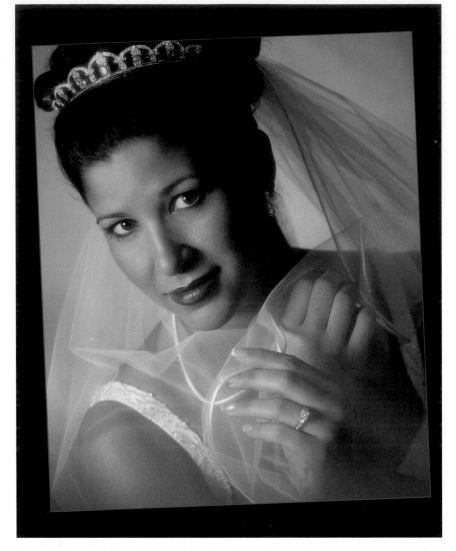

the portrait is best displayed at the entrance to the reception. Another idea is to have a large mat around the portrait so that guests can sign their names around the picture.

Children. Photographing young children can be a real challenge. You must be very fast and have at least one assistant helping during the session. It is usually best to have the mother bring the child into the studio several days before the session for a clothing consultation; this allows the child to become somewhat familiar with you and the surroundings. This is a perfect time for you to remind Mom to think about where in her home she would like to display a wall portrait.

Creating a fun, positive atmosphere in the camera room will be the start of a pleasant buying experience for the client. Be sure that when the client leaves the studio after the session, they have a full understanding of all their options concerning size, finish, frames, etc.

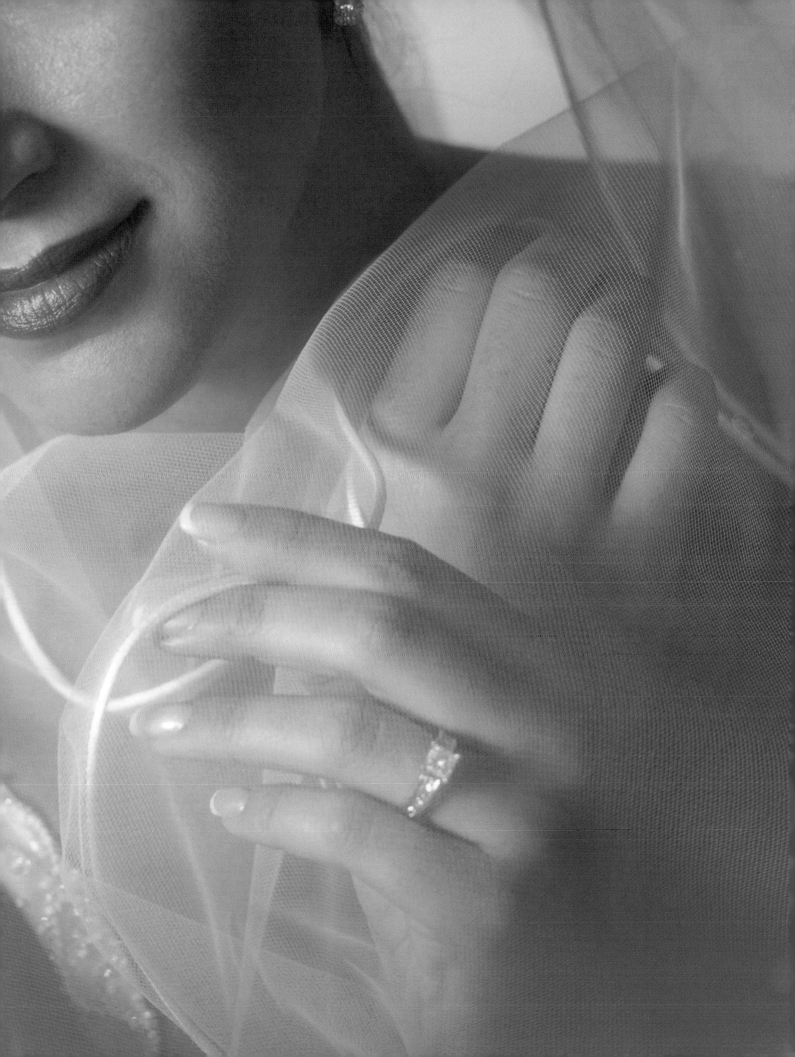

This information is for YOU, the parent

Your son/daughter has reserved the studio at *Williams Photography* for the creation of his/her senior portraits. In order that we may provide our best possible service to you, this letter contains information that you, the parent, need to know. As you may know, *Williams Photography* is not your "run of the mill" portrait studio. If this is to be your first *Williams* experience, you will probably find that our methods are a bit different, but the results and our reputation speak for themselves. Please take the time to read this information thoroughly and make sure that you and your senior are prepared for the creation process. There are many details in creating great portraits and *Williams Photography* will handle most of them. However, you are in control of some of the most basic and critical aspects.

Your investment in *Williams Photography* portraiture today will be cherished for many, many years. We are always hearing from our clients who say their *Williams* portraits have brought them hours of enjoyment — especially once their son or daughter is out on their own. We are sure you will find it to be true, and we ask your full participation and cooperation in making the creation of such an enjoyable heirloom.

Great portraits don't just happen. They are a result of efforts on both sides of the camera. Your studio reservation is a private creation session with our photographer and staff. We will be ready for you. Please be ready for us.

- Please instruct your senior to treat this reservation as they would any important appointment. It's a production in which they are the star. They should be ready and on time. When you reserve the studio at *Williams Photography* the studio is yours for that period of time! If for any reason your senior will not be able to keep their appointment, please call the studio. We do offer this word of warning. *Williams Photography* reservations are in high demand and it's not unusual that rescheduling can't be done until October or November.

- We recommend not scheduling other activities on the day of your reservation. Rushing in for a session, or "clock-watching" while you are in the studio can stress and fatigue you and your senior. Stress and fatigue can be reflected in the finished work and there's no magic wand which can remove that!

- We have sent a packet of very detailed information directly to your senior. Your portraits will reflect the thought and effort you put into them, so PLEASE READ THAT INFORMATION COMPLETELY. Elements of the portrait which are controlled by you include: sunburn, hair styles/facial hair, nail polish, wardrobe selection, jewelry, make-up, etc.

- One last note. If you wish to "match" a pose or look we have done before, please bring the appropriate items, a copy of the print you wish to match, and let the photographer know your wishes before the creation process begins.

We hope this information is helpful to you. Everyone is very busy these days, and our aim is to give you all the tools necessary to make the process smooth and enjoyable, and the results incredible. The "senior portrait" is the quintessential portrait in American life. It will be enjoyed by generations to come, and we're proud to be the artists you've selected to create your portrait heirloom.

◼ SETTING THE MOOD FOR SALES

There are several different methods used today to present photographs to clients. Regardless of the method you are using, setting the right mood for the sales presentation is crucial to maximizing sales.

Before a client comes in to place an order, they should have a complete understanding of the price sheet, print finishes, payment options, delivery times, and anything else involved in the order process. How do we make this happen? All of our clients are sent a packet of information including prices and policies when they call to book an appointment for a photo session. All photo sessions are paid in full when they book their

Our parents' flyer lets parents know what to expect and what they can do to help ensure great images.

BELOW—Our flyer called "Express Yourself!" gives advice on selecting props to personalize an image. **NEXT TWO PAGES**—Our senior-portrait clients get lots of tips on preparing for their session.

appointment. When the client comes in for their session, we go over a copy of the price list they received in the mail, show them all the different print finishes, and explain payment procedures, pricing, packages, delivery schedules, etc. When they come back to the studio a week to ten days after the session to pick up their proofs, we go over everything once again and ask if they have any questions about the process. When

Express Yourself !!

We encourage you to bring along ideas or items to personalize your session. Here are some ideas to get you thinking....

- Sports uniforms or equipment
- Pets
- Collections
- Flowers
- Hobbies
- Brothers or Sisters
- Musical Instruments

(Anything that might portray the real you would be great, some items may require an additional session fee.)

Avoid sunburns...We all love the sun, but stay out of it a few days prior to your session. A little color is always attractive, but don't overdo! We cannot change the redness of a burn by artwork.

Wrinkles show...Make sure your clothes are neatly pressed.

We have the **miracle of retouching!** If you wake up the morning of your session with a brand new blemish don't worry!! We have the ability to return your complexion to peaches and cream in the final photographs. Unfortunately, retouching cannot be done on previews. Retouching is facial only, so your hair and clothing should be exactly as you wish them to appear.

Please **feel free to call us** as often as you need to. No question is too simple. We want to make your session as memorable as possible, and we'll be glad to help in anyway we can.

If you wear glasses:

Glasses cause distortion to your facial features. There also may be glare from photographic lights. Any tint to your glasses will darken under photographic lights. It is vital that you do one of 3 things:

1) Ask your eye doctor to loan you a pair of frames like your own. Most doctors are happy to help you with this.

2) Remove the lenses here at the studio and replace them after the session. We can help you do this if your glasses have screws that loosen.

3) Try some photographs with and some without your glasses.

Here are a few helpful hints to make your session successful!!

What do I wear?

For the first outfit, you will want to choose something classic that won't be out-dated in just a few years. It is most likely that a portrait made in this outfit will be chosen as a wall portrait for your home. You may consider discussing this with your parents, deciding in which room the portrait will be displayed to help coordinate your outfit with the colors and formality of that room.

We have found that sweaters, suits and dresses work well. Solid colors or very subtle prints are best in medium or darker tones. This should be the **first** outfit you wear.

After the classic portrait you are ready to **get casual**. The other outfits in your session should truly represent the person you are. You can actually wear something your friends will recognize you in! This is the time to wear the bolder colors or trendy clothing. Below are some points to keep in mind while choosing your outfits.

- **Make sure it fits!** The "super oversized" clothes are in style, but photographically they aren't as flattering. On the other hand, anything too tight may confine you and make you look uncomfortable in the photographs.

- **Color** is one of the most important decisions. Choose clothing colors that are complimentary to your skin tone. If you find people compliment your appearance when you wear certain colors, this may be a good indication of the colors that look best on you.

- Choosing the right **neckline** also is important. If you have a slightly longer neck you should choose a higher neck line, such as a turtle neck. If you have a shorter neck, choose a V-neck or crew.

- Be careful in choosing tops with large **shoulder pads**. They tend to make some people look larger than they are. Make sure you cannot see the shoulder pads through the shirt.

- If you want to appear as slim as you are in the photographs, **avoid horizontal strips!**

- **Sleeveless clothing is not recommended**; it makes arms appear larger than they are. Long-sleeved clothing is the best choice.

- **Sweaters** photograph well all year long. We keep the temperature in the studio comfortable all year, so don't hesitate to choose a sweater just because it is warm outside.

- **If you cannot decide** which outfit to wear, feel free to bring along additional choices and we will help you decide which will photograph the best.

- **Dress from head to toe!** Remember everything you will need to complete an outfit. Socks, hose, belts, shoes and jewelry are some of the most commonly forgotten items.

(Over)

Getting Ready!!

- If you wear **make-up**, apply it as you would normally. If you are a diehard natural and normally do not wear any make-up, we suggest a minimum of gloss on the lips and a little mascara. Retouching is provided on your finished portraits, but to make your previews look their best, covering any blemishes is recommended.

- **Facial shine** is something we cannot retouch so bring along some translucent powder to eliminate any shine.

- It is possible that your hands will show in some of the photographs, so make sure your **nails are neatly done.**

- Avoid a brand new **hairstyle or** cut. Please have you hair ready when you arrive at the studio so only a quick touch up is necessary. Hair **cannot** be retouched so it is your responsibility to style it exactly as you wish it to appear in your finished photographs.

- **(Don't hesitate to call the studio if you have any questions!)**

Get ready for the "Great Outdoors! "
Here are a few tips to make your outdoor portraits fabulous!

- **Do not wear your outdoor outfit first.** We normally photograph you outside last in case it is warm and the wind blows your hair.

- We normally work with **one outfit outside**. However, if you prefer outdoor portraits we could use two outfits outside.

- **Casual clothing is best**. It simply seems more appropriate for outdoor photography. Poses taken down in the grass often are favorites, so make sure you wear something you can get on the ground with.

- Wear **colors that you see in nature**. Greens, blues, browns, tans, rose, burgundy and rich violets are perfect. Avoid white and black!

- **Jeans and sweaters** are truly an ideal choice. In selecting a sweater remember the earth tones mentioned above. Also look for medium to darker tones in solid colors or subtle prints. (We photograph seniors in sweaters all summer long. We work quickly outside so you won't be in heavy clothing too long.)

they make their appointment to place their order, they are once again asked if they have any questions about packages, prices, etc. When they come in to place their order, there are no surprises. They have an idea of what they want and how much it is going to cost. This, of course, makes the sales process much smoother and more pleasant for both the staff and the client. Nobody likes surprises when it comes to buying something!

Be certain that neither the salesperson nor the client are distracted during the sales presentation. Comfortable chairs, pleasant soft music, and wall samples of different size prints and finishes will greatly enhance the presentation.

After several months of selling, your salesperson should be an expert. If not, you'd better find someone who has a knack for selling. For the most part, the questions and concerns raised won't vary much from client to client, so a well-rehearsed presentation addressing all of

Nobody likes surprises when it comes to buying something!

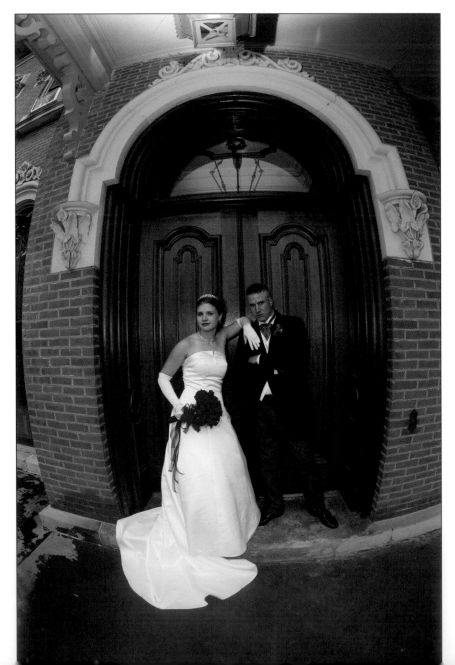

If you want to succeed in photography, you must become an excellent salesperson—or hire someone else who is.

the elements of the sale and product should cover the bases. Over the years, many studio owners have told me that when they had an excellent salesperson, their gross sales topped those made by a person with average skills—even though all of the images were created by the same photographer. When hiring a salesperson, select a candidate who has experience selling to people with discretionary income.

■ MAKE IT EASY FOR THEM TO GET WHAT THEY WANT

Don't make your pricing and policies difficult for clients to understand. You'd be surprised how many price lists from other studios I've seen that even *I* don't understand—and I've been in the business over twenty years! When you create your price list for weddings, high-school seniors, families, etc., keep it simple. Don't implement a lot of rules and policies that confuse and distract the client from getting what they want. Clients must be comfortable with your price list and should completely understand what they are getting and paying for.

Having some flexibility built into your prices will give your salesperson some room to move a little on the prices if necessary. Many times, you can use this to move a client up to the next level if they feel they are getting more value for their money. You want all your clients to leave the studio thinking they got the best-possible product, for a fair price.

Don't implement rules and policies that confuse and distract the client.

■ THE SALES PRESENTATION

Gently guide the client from one product to the other, making sure they are getting everything they came in for. You are simply helping them get what they want. Listen carefully to the client when they are placing their order. To encourage clients to add on to their order, ask questions like the following: Would you like to look at some frames for your wall portrait? Would you like your daughter's name and graduating year on her wallet poses? Did you know that you can buy all of the previews for a discounted price?

■ KNOW WHEN TO CLOSE THE SALE

Once you have presented all of the products the client may be interested in, it is time to close the sale. Closing the sale is a crucial component of the sales presentation and positively impacts sales.

Begin to close the sale by reviewing the client's choices, making sure that the order is exactly as the client desires. You may want to say something like, "Okay, Mrs. Smith . . . you want the ultimate senior package for your daughter. That package offers our greatest value." Create

excitement and stress the value of their purchase. We usually tell our clients, "The longer you have these portraits, the more valuable they will be to you. You will treasure these photographs forever." You now have helped convince them that their purchase is justified and that they have gotten tremendous value for their money spent.

Next, allow the client to ask any questions. Consider saying, "I think we have covered everything. Do you have any questions?" Once you've gone over any last-minute concerns, continue with, "Your total is $1100.00. How would you like to take care of the balance? We do accept credit card payment."

Finally, thank the client for their business by making a statement like this: "Thank you so much for your business. You can expect to be notified in approximately six weeks that the portraits are ready to be picked up. Thank you again for choosing our studio."

If you stray from the task at hand and do not close the sale, the client may begin to feel uncomfortable and may have second thoughts about what they are buying. With a close, your client has been reassured of the value of their product and is excited about their purchase.

LEFT—A high-impact background will add some real pizazz to your portraits of high-school seniors. **RIGHT**—Only two lights were used for this image—a blue background light and one light on the face. The 5:1 lighting ratio creates a very dramatic image.

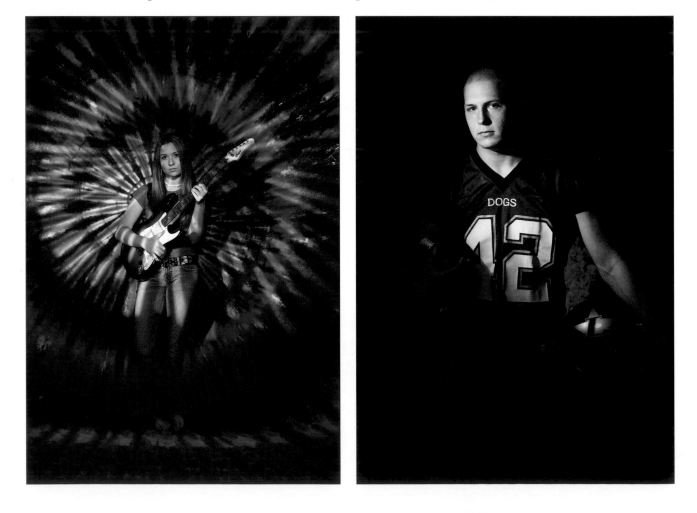

7. THE TELEPHONE

*T*he telephone is the single most important piece of equipment in your business! It is the device that all of your business and money flow through. Yet, unfortunately it is neglected by many studio owners.

■ ANSWERING MACHINE

Far too many studios rely on an answering machine to take most of their calls. We have actually had clients surprised that a real person answered their call. They have called other studios for wedding dates, prices, etc., and gotten an answering machine most of the time.

Here is a little test you can conduct to find out how good or bad your competition is at answering the phone. On a Tuesday, Wednesday, or Thursday (many studios are closed on Monday or Friday), call all of your competitors in the yellow pages during business hours. I guarantee you that about 70 percent of the time you are going to get an answering machine! We have done this several times in our area and every single time we come up with the same results. when your machine picks up, what you are really saying to a client is, "I will talk to you when it is convenient for me, not you." I can't even imagine how much business we have gotten over the years just by doing a basic thing like answering the telephone.

■ ETIQUETTE

Answering the telephone correctly will also set you apart from your competition. I'm always amazed at how poorly most business tele-

I'm always amazed at how poorly most business telephones are answered.

phones are answered (if they even get answered at all). Randomly call many types of businesses from the phone book, and you will find out how *not* to answer the phone. Remember, the telephone is usually the first contact a client has with your business. If you have a person with poor telephone skills answering calls at your business, over time it will cost you thousands and thousands of dollars. For instance, I have one business associate I call occasionally who owns a photography studio. Regardless of the time of day, the first thing I hear when his receptionist answers the phone is "good afternoon." It might be 10:15 a.m., but at his studio it is "afternoon." I've mentioned this to my friend several times, but nothing has changed. Do you think I am the only one who has noticed this? You should take a long, hard look at how your telephone is being answered.

The telephone is usually the first contact a client has with your business.

Here is some basic telephone etiquette that will help you be more professional sounding to your clients.

Begin by answering the phone by the third ring. Speak slowly, clearly, and concisely, saying, "Thank you for calling _____ Photography. This is _____ speaking." You have thanked the caller and told them who they are speaking to. Most of the time, the client will call you by name before they address what they are calling about.

Before assigning anyone to your telephone, be certain they have been trained or have lots of experience dealing with clients over the phone. Mastering phone skills, like mastering sales skills, takes time and practice. Don't allow employees to practice their phone skills on your clients. Be sure they are properly trained. A pleasant, well-trained person on the telephone can be a real asset.

There are certain phrases you should *never* use with a client:

1. **"We can't do that."** What a thing to say to a client! Instead say, "That might be difficult," or "Let me see what we can do." If possible, find an alternative solution.
2. **"You'll have to . . . "** The only thing a client has to do in life is die someday! Instead, say, "You'll need to . . . " or "Here's how we can help with that." Offer advice, but never say a client *has* to do something.
3. **"I don't know."** Instead, say, "Let me check on it, and I will let you know as soon as possible."
4. Never say **"no"** at the beginning of a sentence. Try to turn your statement into a positive response. An example might be, "We would be happy to replace the product."

5. This is the one you hear all the time when you call a business: **"Hang on a sec. I'll be right back."** Instead, you should say, "Mrs. Smith, may I put you on hold for a minute or two?" Hopefully, you have a message system with music for your clients to listen to while they are on hold.

◼ SOUND LIKE A REAL PROFESSIONAL

If you want to sound like a real first-class operation to a new client, have a phone system installed. A phone system is a piece of equipment that takes the place of your answering machine. It gives you the ability to have a message play when you put one of your clients on hold or if all of the incoming lines are busy.

We have two different messages on our system. The first message comes on if both of our phone lines are busy and tells the caller we are currently busy, our business hours, and that we will call them back as soon as we can. Since we have two lines, plus a fax line, coming into our business, clients seldom get our voice-mail system during regular business hours. The second message is heard when a client calls and is put on hold. Having dead air on the telephone with a client on the other end is something I would definitely not recommend, since the client may not be sure whether or not she is still on hold or has accidentally been disconnected.

A quality phone system costs approximately $1500.00 to $2000.00. The systems are all digital and have very good sound quality, unlike an old answering machine with a tape player. You can further enhance your phone system by having a professional voice talent create your messages. I strongly recommend this. Also, be sure to use a female voice in your messages. Most of your clients will be female, so it only makes sense to have a female's voice on your system. You won't hear a man's voice if you call Victoria's Secret. A telephone call to your studio is, in many cases, the client's first contact with your studio, so do everything in your power to ensure that you create a good impression.

To sound like a real first-class operation, have a phone system installed.

8. DIVERSIFICATION IS SO IMPORTANT

*W*e are not located in a large market area, but we are still surrounded by many full- and part-time photographers. In our newest phone book, there are over forty photographers listed in the yellow pages—and don't forget there are many more part-timers without listings in the yellow pages. To operate a photography studio in a small town without offering a lot of different types of photography would make it difficult to earn a good living in this business. At our studio, we photograph high-school seniors, high-school sports, school dances, underclass photography, weddings, family portraits, sports leagues, and occasionally products. In this chapter, I will give you all the information you need to be successful in these types of photography. In the next chapter, we'll cover the marketing strategies you can employ to draw the different client demographics.

You don't need a studio located on a busy road to be successful.

◼ HIGH-SCHOOL SENIORS

At least half of our gross sales stem from photographing high-school seniors. As you are probably well aware, there are entire books written about how to photograph and market to high-school seniors. There are many things that will determine your success with this type of photography.

Keys to Success. You may think that location is the big factor, but you don't need a studio located on a busy road to be successful with high-school seniors. I know of studios located in highly traveled commercial districts that are surrounded by thousands and thou-

Multiple-image photographs are always a big hit with high-school seniors.

sands of high-school seniors but are struggling to draw fifty clients. On the other hand, there are studios that are tucked away in the country and photograph hundreds of seniors each year.

From what I have seen, location really doesn't have an effect on the number of seniors you can get through your door. I don't know of anyone who has all of the answers as to why some studios flourish with seniors while others fail. Attend seminars that specialize in high-school seniors. Some of our best materials have come from attending such pro-

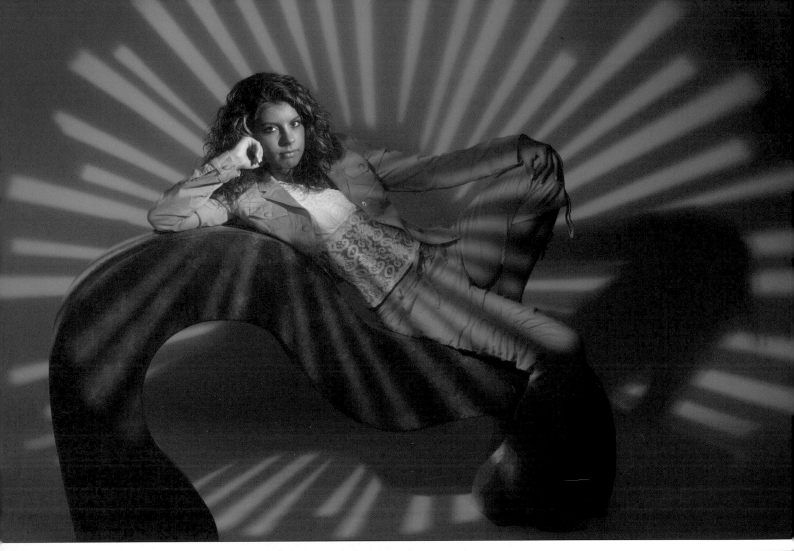

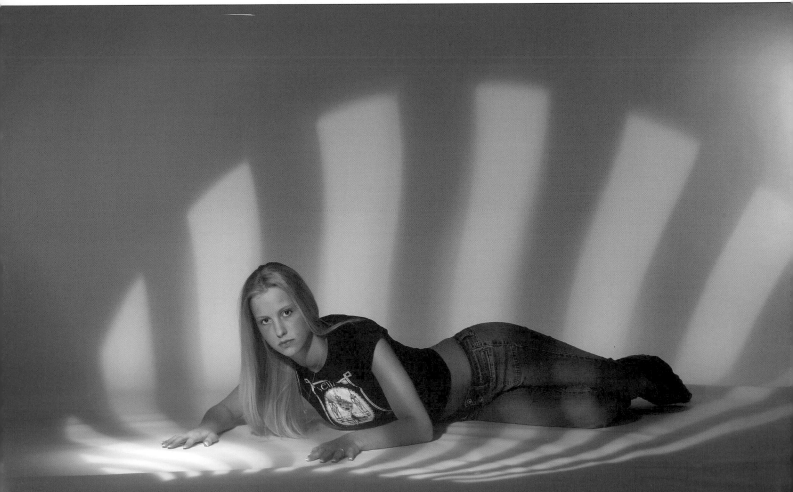

grams. Just a word of caution: some of the speakers I have heard over the years get a little loose with the truth. Inflated sales numbers and other exaggerated claims are sometimes hard for the beginner to detect. I know of one studio located about fifty miles from ours that claims they are one of the most profitable studios in the country! Not the county or state, but the *country!*

So what are the key elements for success? Well, all of the studios I know that do a lot of business with seniors do a lot of direct mailing. Getting the word out to the high-school seniors that you want to be their choice for senior pictures is critical. The most effective way to do

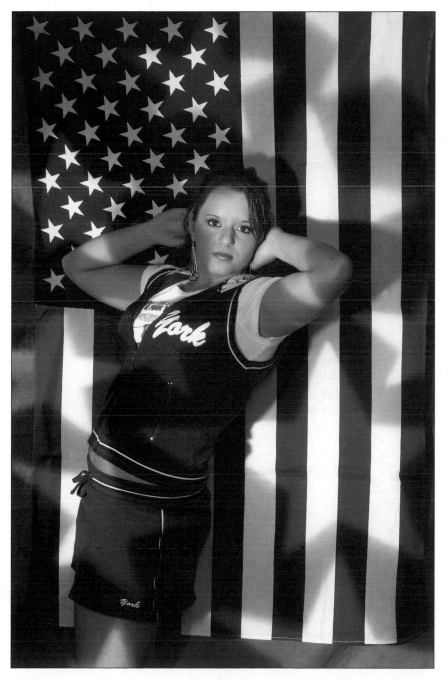

RIGHT AND FACING PAGE—In this series of images, a projection device with colored gels has been used to create the different patterns and designs. Also, a spotlight has been used on the face only, so that the color of the gel does not appear on the subject's face. Be sure the spotlight is approximately one stop brighter than the color of the gel to get the desired effect.

this is via direct mail. Another good way to get their attention is with a mall display that features senior portraits. (We'll take a closer look at marketing in the following chapter.)

The experience that the students have in your studio is probably just as important as the pictures they receive. Word of mouth will make or break you with the seniors. Success in this category is, I think, simply a matter of personality. If you are uncomfortable with seniors or simply find it annoying to talk with them, it will be easy for them to detect. Reading all of the books on seniors and attending countless seminars will not change that facet of your personality. Today's high-school seniors are very mature, and they know what they want. All I do is talk to them like I would any other adult. Find out what your clients' interests are and talk about them. I'm always amazed at what some of the students are involved in. I personally enjoy being in their company. You will soon know if you are comfortable around high-school seniors.

Session Fees. We offer many different types of sessions for seniors—from a basic head-and-shoulders session all the way up to an indoor and outdoor session, black & white session, and sessions with cars, friends, sports gear, or just about anything else you can think of. Session fees are certainly not big money makers, but I think you should charge according to your time and the number of proofs or images they are going to see.

Booking an appropriate block of time will provide for a good experience for the student and keep you on schedule throughout the day. Some photographers let the seniors bring whatever they want with no regard to time and materials. However, to run a smooth operation, you need to know how much time you will need to spend with each client. Therefore, when the senior or parent calls to book their session, we find out what they want included in their photographs. This determines how many session modules they are going to need. We have used session modules for many years and find it to be a good way to control session times.

In our studio we offer three main session types or modules and four add-on sessions or modules, as shown in the brochure below.

Session Fees

Basic Sitting - $40.00
You see 6 previews of head and shoulder poses only.
Wear 1 outfit.
Time: Approximately 20 minutes.

Standard Sitting - $65.00
You see 8 previews which include head and shoulder poses and a variety of other indoor poses and backgrounds.
Wear 3 outfits.
Time: Approximately 45 minutes

Deluxe sitting - $85.00
Our most popular sitting. You see up to 16 previews which include head and shoulder poses, and a large variety of indoor and outdoor OR all indoor poses and backgrounds. Wear 4 outfits.
Time: Approximately 75 minutes

Add-On Sessions

Available only in conjunction with one of the above sittings.

Black & White Glamour sitting - $55.00
You see up to 8 close-up black & white glamour previews.
2 outfits.
Time: Approximately 30 minutes

Friends / Pals - $45.00
Bring your best friend, boyfriend, girlfriend, sister, brother, or pet. 1 outfit. You see up to 6 previews
Time: Approximately 20 minutes.

Special Activities - $45.00
Have your picture taken with your sports gear, trophies, plaques, band instrument or you can even bring your car, truck or motorcycle. You will see up to 6 previews.
Time: Approximately 20 minutes.

Two-Tone Session - $55.00
Only at Williams! You see 6 previews in 2 exciting colors: Obsession Brown or Denim Blue, or get 4 of each color. It's your choice! Time: Approximately 20 minutes

In our studio we offer three main session types or modules and four add-on sessions or modules, as shown in the brochure on the facing page. Using this system keeps me on schedule and gives the client the ability to book exactly the type of session, or sessions, they want.

Don't get caught in the trap of spending three hours photographing a senior only to have them buy a $200.00 package. Institute a minimum order if you are spending over two hours on a session (or set the session fees high enough to cover your time).

Several years ago we began to require that all session fees be paid in advance of the client's appointment. The client can either make a credit card payment by phone when the session is booked or submit payment by mail. If they choose to send the payment in the mail, we send out a reminder card stating that the session fee must be paid by a particular date (usually, one week after the session is booked). The card goes on to say that if payment is not received on time, their spot will be lost. Hardly anyone has ever complained about paying in advance—and it just about eliminates no-shows.

Our summer specials flyer offers seniors significant savings.

Customer Service at the Session. After the senior has booked and paid their session fee, we send out a complete packet of information. Included is a letter confirming the date and time of their session, directions to the studio, a price list, and a list of any specials we may be running. We also send out a separate letter to the parents about the photography session their child is going to have. The day before the senior is to come in for his session, we call to remind him of his session date and time and ask him if he has any other questions or concerns.

When the senior arrives at the studio, we have everything ready for him to have a great experience. We have his name on a sign outside the studio and on the dressing room door. He is greeted at the door, and we help bring all of his things in from the car. To most high-school seniors, getting their portraits taken is a really big deal.

Before we start the photo session, one of our salespeople will explain the complete process—to both the parent and the senior. Everything from how they will see their pictures, the prices, different finishes, and delivery schedules is ex-

plained. The more information you can provide, the fewer problems you will have. Be sure everyone understands payment policies, delivery times, etc.

When we start the session, I ask the senior if they have any particular pose or background in mind. Most of the students leave everything up to you, but once in a while you will get a request for something they have seen. Try to provide a fun experience. If a parent is in the camera room, get them involved—let them look through the camera, ask their opinion. Creating some excitement during the session will pay dividends in the sales room.

At the end of the session, ask the senior if he has gotten everything he wanted. Most students will thank you and say, "I can't wait to see my pictures."

Proofs Presentation. Once the session is complete, the next step is the proofing presentation. Some studios do the selling the same day of the session. We have seniors come back to view their images in about ten days.

To present the images, we still use paper proofs, presented in a book with four images to a page. Some studios do not allow their clients to take the proofs out of the studio, but I think this is a mistake—just be sure the client has left a hefty deposit before they walk out the door. At our studio, we require a $300.00–$400.00 deposit (based on the number of session modules the client had). Of course, you must be sure the customers understand any deposit policy before it is required. In our experience, many students go on to buy the proof album with their order.

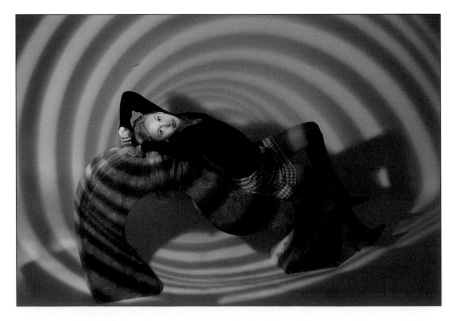

You can build excitement about the images by getting the senior and their parent(s) involved in the creative process—just ask for their input and ideas.

During the proofing presentation, we once again go over the pricing information, print sizes, and finishes so when clients are ready to order, there are no surprises. For most of our clients, high-school senior pictures are a big investment. The better they understand the process, the more comfortable they will be when they come back in to make their final purchase.

Placing the Order. When the client arrives to place their order, the sales process generally goes smoothly because of everything we have done before this visit. In the sales area, we have four large prints of the same person so the client can clearly see the difference between the various print sizes. This is a great aid in selling larger prints.

Having an employee who is well groomed, nicely dressed, and good at sales is essential if you are going to have above-average sales. People will buy from people they like and trust.

During the sales process, offer suggestions and listen carefully to what the client wants, then simply help them get it. At the close of the sale, thank the client for their business and inform them when they can expect the final product. We require about 75 percent of the final order be paid before it is processed. Most people realize that due to the custom nature of the product, this is not an unreasonable request.

Delivering the Order. In approximately six weeks, we call the client to inform them that the order is complete. Since we do all business by appointment, we set up a time for them to come in. If they have purchased an 11 x 14-inch print (or larger), on the day of their visit, we will have it displayed on an easel. This always creates some excitement for the client when they walk in and see their son or daughter on display. It's all about the sizzle, and this is just another way to add pizazz to your studio operation!

All of the products the client receives are also beautifully packaged, and all photographs are either placed in folders or mounted, depending on the size. We carefully go over each clients' order to ensure the client is completely happy with their purchase. If you have done everything correctly, chances are quite high the next time this family needs photography services they will call you.

◼ YEARBOOK PHOTOGRAPHY

Working with high-school yearbook advisors for over twenty years has given me a little insight into what they want. I have been very fortunate to work with wonderful yearbook advisors. Several years ago, my all-time favorite advisor, Carol Mazanetz from Newton Falls High School,

> The better they understand the process, the more comfortable they will be.

took over a yearbook that was tens of thousands of dollars in debt. Today, the school has a beautiful, debt-free yearbook. I still remember the day back in 1994 when she called us to do the yearbook photography. I hope we have contributed to her success in some small way.

Service is the key word when dealing with the advisors. They have one of the most difficult extracurricular activities in the school; every year, they must deal with the yearbook publisher, a new crop of students, the photographer, teachers, and school administration, and, to top it all off, must sell ads to help pay for the book! For them, it is a year-long process, with very little extra pay. The yearbook comes out at the end of the school year or in the fall, then the whole process begins again. Needless to say, with all of this pressure, the last thing they need is a photographer who delivers excuses instead of service.

Sports. You will find that most yearbook advisors want the same thing for their yearbooks. First of all they want good, clean, sharp images of all of the sports action. We provide yearbook sports photography to several schools, including all the game action from football,

To get excellent sports action images, you'll need a 35mm digital camera that can shoot at least four frames per second with autofocus, a 200–300mm lens with a f/2.8 setting regardless of what zoom level you are set on, a 28–105mm zoom (again with a constant f/2.8 lens opening), and dedicated flash system.

Providing excellent game action images to your contract schools is a must. Always be sure to capture all of the players, not just the outstanding ones.

track, cross country, volleyball, boy's and girl's soccer, boy's and girl's basketball, softball, and baseball. Photographing sports action takes skill, a little bit of luck, and top-notch equipment.

To get excellent sports action pictures, you need the following equipment: a 35mm digital camera that can shoot at least four frames per second with autofocus, a 200–300mm lens with a f/2.8 setting regardless of what zoom level you are set on, a 28–105mm zoom (again with a constant f/2.8 lens opening), and dedicated flash system. Probably the only time you will use your flash is when you are photographing night football games. Using a flash during volleyball and basketball is sometime prohibited by the referees. Although I don't find it necessary, some sports photographers like using a monopod rather than handholding the camera.

Even with a 1600 or 3200 ISO setting on your camera, the f/2.8 opening is imperative for indoor volleyball and night football photography. Fast shutter speeds of at least $^1/_{250}$ second are needed to stop the action, so you have to gain the light you are losing to the shutter speed with a large aperture. Sometimes you can get the action stopped with a shutter speed of $^1/_{125}$ second, but I have found that $^1/_{250}$ second works *all* the time. You will use the long, fast lens on all of your game action except basketball and volleyball. Although the long lens works *okay* for these two sports, I have found that a shorter zoom is preferable.

If you have not done a lot of game action work, it is going to take some practice to get good results. Your biggest problem will probably be staying focused on the player or players and not the background. With fast-focusing autofocus cameras, it is very easy to have a player run

past your focus point when you fire the camera, giving you tack-sharp spectators and a blurry subject in the foreground. Like anything else, the more you do it, the better your get.

Something that yearbook advisor Carol Mazanetz taught me was to be sure to get *all* of the players, even the ones sitting on the bench most of the time. After you have gotten the game action shot with a lot of the main players, get the other players in a huddle or walking on or off the playing field/court—but be sure to get all the players, not just the superstars. Everyone likes to be in the yearbook, so photograph everyone and let the yearbook staff decide who they are going to include.

Also, it is best to give the advisors the game action as you photograph it rather than waiting and giving it to them all at once at the end of the season. With digital photography, it is much easier and more cost effective to give the advisors a CD of each game. You can quickly delete the poor shots and supply only the very best action shots. And don't wait until the end of a season to start covering games—sometimes outdoor games will be cancelled due to bad weather, so you want to leave yourself a buffer of time. Waiting until the last minute is usually not a good plan for anything.

Clubs and Organizations. Yearbook advisors will also want you to photograph all the clubs and organizations at the school. Being prompt is imperative; the advisors will have schedules for each club and organization throughout the day. I know of a photographer who was scheduled to show up at a local airport to photograph the high-school senior class in front of an airplane. The school bused all of the seniors to the airport only to find the photographer did not show up for the class pho-

Be sure to provide yearbook advisors with a CD of sports action images on a game-by-game basis, rather than delivering all of the sports images for the year at once. Advisors have a lot to juggle, and anything you can do to lighten their workload will be appreciated.

When photographing a large high-school band, be sure to shoot from a higher camera angle so that you can see everyone's face.

tograph. (No, he didn't have an accident on the way to the job.) Needless to say, he no longer has the contract for that high school. Photographing the groups in different settings always looks better than just placing them in the high-school gym bleachers. Of course, this will be the decision of the advisor. Prompt, courteous service will pay big dividends to both you and the school.

School Dances. Photographing high-school proms, homecomings, winter dances, etc., is something that you usually do for the schools you are doing the sports and yearbook photographs for. To run a smooth operation at a school dance requires a great deal of organization. I strongly recommend starting out with small dances before you move on to a job with over one-hundred couples. Without experience, you are asking for trouble. There are many ways that dances are handled by photographers. I will tell you what has worked well for us over the many years we have photographed these events.

Planning. When a dance is booked for your studio, the first thing you want to find out is approximately how many couples will be in attendance. This will determine how many assistants you need and the number of background setups you will require. If twenty-five or fewer

Photographing proms requires both organizational and photography skills. Notice how the subjects in this prom picture have a pleasing light ratio on them. This is created by using a fill light set at about f/8.0 and a main light of about f/8.7.

couples are attending the dance, you can handle the posing, taking photographs, and giving change on your own. For twenty-five to seventy-five couples, I recommend that you utilize an assistant to give change and direct the couples. When we have a dance with over two hundred couples, we have up to seven people working to keep things moving so the students do not have to wait in line any longer than twenty minutes. Be sure to bring plenty of change—dollar bills and fives (the bigger the job, the more you will need). For the bigger dances, bring at least several hundred dollars worth of change.

A dance with two hundred to two hundred fifty couples can be serviced with one background and one photographer, providing you have enough help working the dance with you. As mentioned earlier, several people should work the line, make change, pose, take the dance envelopes, etc., to keep things moving. When photographing dances with more than two hundred fifty couples, you will probably need an

additional background. The thing to remember here is it's not how many backgrounds you have set up but how efficiently you can photograph the students. A good crew with one background set up could photograph two hundred fifty couples quicker than a poor crew with two backgrounds set up. As a guideline for you, with a good crew, we can photograph a couple about every twenty to thirty seconds.

Background Selection. Find out the theme of the dance, as this will give you some idea what type and color background will be most appropriate. We try to use colors that will look good with any color of dress that the girls may wear. Light grays, tans, and other soft colors always look good; bright colors generally do not. Select a background that creates depth. For full-length couple shots, you will need a background that is 10 feet wide by 15 feet long.

Lighting. I recommend using at least a two-light setup. Using only one light will create flat light and simply will not be as attractive. I set my fill light (at f/8.0) behind the camera and the main light (at f/8.7) off to one side. This gives you an overall reading of about f/11.2 with about a 2:1 ratio on your subjects. Set your camera at f/11 and your shutter speed at $\frac{1}{125}$ second. (These settings will vary slightly with digital, but they are close. Check your histogram on your digital camera to ensure you have achieved the light ratio you want.) Sometimes, depending on the background, we may use three or four lights on the background. Something I learned from my brother is to direct the traffic flow away from the cords and lights. This keeps the couples moving through with less risk of tripping.

Subject Placement. Place the couples about 5 feet from the background. When cropping your subjects in the camera, be sure to allow some space at the top and bottom. Having the subjects' heads too close to the edge of the frame will not look good.

Lens Selection. You will want to use a normal lens for this type of photography. Long lenses require you to work so far from the subjects that, many times, they can't hear your instructions.

Blinks. If you are shooting the job with film, you'll want to be sure that you have no blinks recorded. Have your assistant watch one student while you watch the other one. If you see a blink, of course, you will want to take the picture again. If you are using a digital camera, you can check for any blinks on the LCD screen.

Group Pictures. At most dances, many students will want their photographs taken in large groups. We do not photograph any groups until all of the couples have been photographed. This is clearly indicated on

Many students will want their photographs taken in large groups.

the price list and envelopes that the students receive at the school. The reason for this is that it takes more time to photograph a large group than a couple. Also, you would have to keep moving the main light backward for a group and closer for the couples, and this would slow down the job.

Include a separate package on your price list for group pictures. We charge $8.00 for each person who wants to buy the picture. We do not charge students if they are in the picture but don't want to purchase it. Not everyone who is in the picture is going to buy it. Group pictures at school dances can generate several hundred dollars in sales.

Candids. More than likely, you will also want to take candid photographs of the dance for the yearbook advisor. Try to get as many students as possible in the pictures. Remember, everyone likes to be in the yearbook.

End of the Shoot. Always have the disc jockey announce a last call for pictures before you start to take down your lights. Before you leave for the evening, be sure to contact the teacher in charge of the dance to let her know when she can expect the pictures to be delivered to the school. Our normal delivery time is about three weeks. Package the pictures neatly, and put them in alphabetical order so they can be passed out easily to students. Remember, just about everything goes back to service.

Staying Open the Night of the Dance. Many times, a photography studio close to the dance location will open on prom night, hoping that the students will have their pictures taken at their studio instead of the dance. The studio owner has students pass out flyers stating that they will be open on dance night. Although you may get some students to come into your studio, this may very well backfire on you much later. If and when the school is looking for a new photographer, any ill will you created with the school by opening your studio on dance night reduces the chances you'll be considered for the contract. If you have no desire to be considered for a school contract then, by all means, open your studio on prom or homecoming night, and get as much business as you can. If you are getting the students photographed quickly, chances are you will be photographing most of the students at the dance—if not all of them. Don't give the students a reason to go anywhere else.

One Studio or Several? Some school administrations make it very difficult for the yearbook advisor to produce a quality yearbook. He or she must try to get photographs from many different sources to put out a quality book. I think most school yearbook advisors would agree they would rather deal with one photographer than four or five different

Have the disc jockey announce a last call before you take down your lights.

ones. If you get the opportunity to work with a yearbook advisor, therefore, be sure to give them excellent service all the time.

When dealing with a high school, be sure to find out exactly what is expected of you and what you will get in return. We were once hired by a high school to do the individual sports packages and all the game action images for sporting events, and to photograph all of the clubs and organizations for the yearbook, as well. The job of photographing the school's two dances, a much more profitable assignment, was being handled by another studio, whose responsibility it was to show up one night, photograph the dance, count the money, and deliver the pictures three weeks later. We, on the other hand, had to constantly haul our equipment to the school to photograph various groups and events.

Difficulties that arise in multiple-photographer situations are generally due to a lack of communication, caring, or understanding between the yearbook advisor, school administration, booster clubs, and the various teachers involved with the dances, sports, etc. You may want to agree to an arrangement like this in hopes of getting the entire job or until another school calls you for all of their activities, but be aware that such a job may present some drawbacks.

Contracts. A contract is an agreement between a photography studio and a high school. You provide sports, dance, club photographs etc., for the school, free of charge, and in return, you get to photograph all of the packages that the sports and band students purchase. In addition, you are given the privilege to photograph the prom and homecoming dances. Of course, you don't want to give away the farm—remember, you are in business to make a fair profit.

Believe me when I tell you that what these contracts entail varies greatly from school to school—both in terms of what you are expected to do for the school and what you will get in return. For instance, some schools photograph yearbook pictures for free as part of their contract. However, I've chosen not to engage in such an agreement. While there are pros and cons to offering this service (you photograph all the seniors for free but increase the likelihood of winning the students' business when it comes time for a paid session), we really don't want seniors coming to us because they feel they have to. We want to cater to a higher-end clientele who want a high-quality product with superior service.

Coordination. In some schools, the athletic director, band director, prom advisor, homecoming advisor, multiple coaches, and even the booster club president will each hire a photographer to cover their event(s). The yearbook advisor tries to get all of the photos they need

from a variety of photographers, which is a difficult task. You will not usually have these problems at a high school where the yearbook advisor has been on the job for many years. When jobs are broken down in this way, the profit that any given photographer can expect is diminished. You will have to decide if a particular school contract will be profitable. This is a somewhat complex issue. If you are the only studio the school is using, it's probably worth it. If you are just getting a couple of small assignments from the school, it may not be worth your time. Don't get caught in the trap of doing all the free work for the school hoping they will someday call you for the profit work. At two of the schools we service, everything works fine. Unfortunately, they are the exception rather than the rule.

The Advisor. The yearbook advisor's job is usually one of the least desired positions at a high school. Many times the administration will require that a new teacher getting hired take the yearbook position as a condition of employment. The other extreme you usually find is a teacher who has had the job for years and years and has everything down pat. Whether the school hires a single photographer or multiple photographers, the advisor's goal is the same: to produce a superior yearbook each year.

Requirements. The yearbook advisor is going to want excellent photography of all the sports game action that occurs throughout the school year. To photograph all of these sports requires a great deal of time, equipment, and talent on the part of the photographer.

You will also be called upon to photograph the senior class on the school grounds or at an off-site location. I have been on rooftops, up in cranes, and in all sorts of places to produce a unique senior class picture.

Additionally, you will need to photograph all of the clubs, organizations, etc. This usually takes a full day at the school. Candid pictures of the school dances are part of the yearbook as well. Pictures also are needed of the school board members, individually and as a group; teachers; secretaries; plus special sports and hall of fame functions; band parents' nights; sports parents' night; the list goes on and on.

Landing a Contract. Most of the contracts we have acquired over the years have been the result of poor service from previous studios. This type of photography is very political. My brother operated a studio about seventy-five miles south of ours, he lost a school contract one year because the yearbook advisor got a divorce and started dating my brother's competitor! My brother's chance of keeping that school contract was slim to none, and slim just left town!

> You will have to decide if a particular school contract will be profitable.

Do not depend on this type of work for steady income! You never want to have your main income at the whim of a booster president or a new athletic director. Most of the time the person choosing a photographer will choose strictly on price—they assume that the quality and service will all be equal! Knowing the right people certainly does not hurt. Remember, it's okay to get the job because you know someone, but you must still provide a top-notch product with superior service.

◼ SPORTS LEAGUES

Sports-league photography is probably one of the most competitive genres. As with most professions, the lower the skill level required, the more competition you are going to have. The photographic skill-set required for most sports photography leagues is quite basic. Many part-time photographers try to acquire this type of work because you don't need a studio or advanced lighting and posing skills.

When photographing sports leagues, remember that expression is key to parents. These clients tend to be more concerned with price than specialized photo techniques and higher-end imagery. Offering fun designs, like magazine-cover and trading-card layouts, can help boost your sales.

Organizational skills, on the other hand, are a must when photographing a large sports league. Don't even think about taking on a large league of several hundred players until you have the confidence and staff to make everything go smoothly. Most large leagues have a board made up of several parents. Their job is to run the league, acquire uniforms, schedule games, and try to keep parents who think their child is a superstar happy. For the parents running the league, it's a labor of love. They spend many volunteer hours making sure the kids and parents enjoy being in the league.

Many times, somebody on the board will recommend someone they know to do the league pictures, so knowing the right person sure doesn't hurt. If you get the opportunity to present yourself to a board, be brief and to the point with your presentation. Remember, these people are there on their own time. Show them a few pictures and your prices. What you are really selling is yourself. If they don't like you, you are not going to get the job—it's just that simple. The main concern for parents is price. They couldn't care less about any of your awards for beautiful pictures. Basically, what they want is decent pictures, low prices, kids not waiting in long lines, and a fast turnaround time on getting the prints back.

Offer a large variety of packages and various sport trinkets. Sports plaques, balls with pictures on them, trophies, and trading cards, etc., are all popular with the kids and parents. They also provide you an opportunity for additional profits. Be prepared to offer a percentage of your gross back to the league. Most of the larger leagues expect at least 10 to 20 percent of your gross as a kickback. Find out what they want

When working with sports leagues, you are dealing with young children and their parents. Therefore, you will need to be pleasant, have fun with the kids, and above all have an excellent, experienced staff to keep things running smoothly and to deliver the finished product on time.

before you accept the job so that you know how much to raise your prices. You certainly don't want the 20 percent coming out of your profits!

Once you have been offered the assignment, you will want to get a schedule from the league for picture times for each team. Get your picture order forms printed and delivered to the league several weeks before the job. If you are going to be photographing indoors, get phone numbers of several people who can let you into the building. If the person is late unlocking the door, you will be the guy blamed for running behind all day. Have backup phone numbers and expect the unexpected. Remember, you are dealing with volunteers. They have no idea it might take you one hour or more to set up backgrounds and lights, test cameras, and set up trinket displays. If you are doing the photography outdoors, have a backup plan in case of rain. Again, you will need contact people and phone numbers. Nobody is going to make this happen for you. If something does not go correctly, whether it's your fault or not, you will be blamed.

Allow yourself about ten to fifteen minutes to photograph each team. Since we are located in a small town, none of the leagues have more than four- to five-hundred players. On picture day, we have one person photographing the individuals and another photographing the teams. You will also need a person collecting the envelopes and someone posing the kids. Have a large poster of several different poses the kids can choose from—or, if you are really quick, shoot two or three different poses of each player and choose the one with the best expression. Stay organized and have enough help to keep things moving.

After the photography, getting the correct packages printed is very important. You don't want parents calling you after the packets have been delivered complaining they didn't get what they paid for. If you are shooting the job digitally, there shouldn't be any blinks—but you may still have a few parents who want a retake for various reasons. Therefore, you should have a picture retake day set up with the league before the packets are delivered. Usually we just have the very few kids who want a retake come to the studio. It's more flexible for everyone involved.

Sports league photography is not for every photographer. You are dealing with young children and their parents. Therefore, you will need to be pleasant, have fun with the kids, and above all have an excellent, experienced staff to keep things running smoothly and to deliver the finished product on time.

Allow yourself about ten to fifteen minutes to photograph each team.

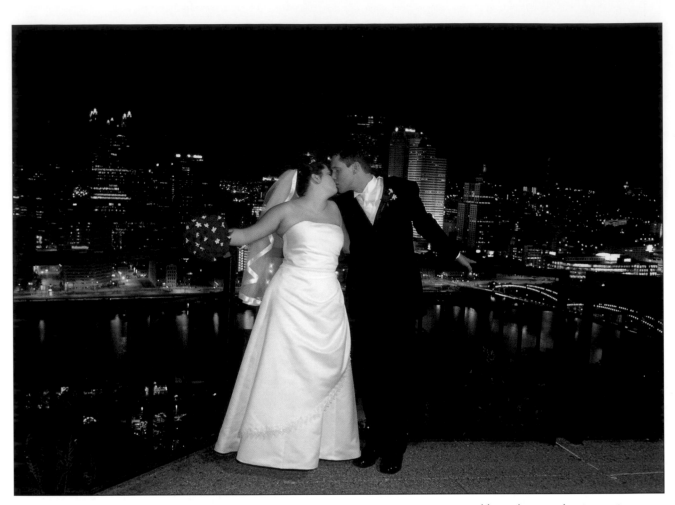

Wedding photography is an important income stream for our studio.

◼ WEDDINGS

Like many other photographers, one of my first paid assignments was photographing a wedding. For those getting into the photography business, weddings are generally the first step—after all, all you need is a camera, a flash unit, and hopefully a backup system.

On the other hand, it's not unusual for a photographer to *stop* doing weddings once they have enough other work to keep the studio busy. I find it rather strange that weddings are the first thing many photographers start with, but it is also the first thing many of them stop doing. For some photographers it's almost like a badge of honor to be able to say, "I no longer photograph weddings."

Weddings are not for everyone, that's for sure. Why do some photographers love doing weddings while others quit the moment they have enough other work? Having excellent photography skills is only a small part of being a successful wedding photographer. In this section, I will explain what works for us.

The Type of Client. As I have mentioned throughout this text, you need to determine the type of client you want to attract. Whether you

are doing fire-hall and VFW-hall weddings or country-club and high-end hotel weddings will be determined by many factors. Price, photography skills, studio décor, phone skills, and service will all play a big part in the type of clients you attract. Don't forget: you must have a very pleasant, likeable personality to convince the bride you are just the person she is looking for. If she doesn't like you, she'll never book the wedding with you, regardless of how beautiful the photography is.

Telephone Skills. Almost all wedding bookings start with the telephone. Of course, we already know that good telephone skills are essential—not only for weddings but across the board. You simply *must* have a person with excellent skills on the telephone.

When a bridal client calls, the first question they usually ask is how much you charge to photograph a wedding. I believe they don't know what else to ask, so they start out with the price question. Many times they will ask for a price before they even know if you are available!

We'll assume that you are not a low-end wedding photographer and that the prices you are charging are for the average to higher-end client.

Our clients are upscale and generally spend a substantial amount of money for their wedding photography.

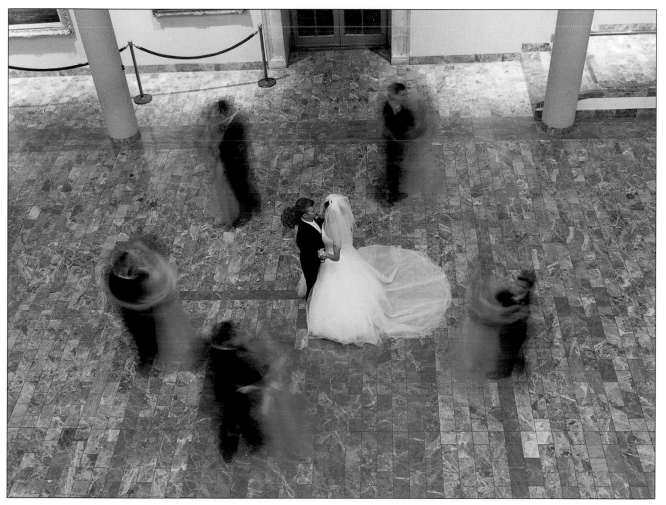

The best way to deal with a wedding call is to engage the caller with questions about their upcoming wedding. By doing this, you are showing an interest and qualifying the client. Our calls generally go like this:

1. "Congratulations, Lisa, on your upcoming wedding. What is the date?"
2. "Where are you getting married?"
3. "Where is the reception going to be?"

By engaging the caller with questions, you can determine if they are going to be interested in your services. If they are calling in response to your yellow pages ad, chances are they will select a wedding photographer based on price and nothing else. They are looking for what I call the "BBD" ("Bigger, Better Deal"). Quality and service are not important—they just want the cheapest photographer they can find.

When, on the other hand, a bride calls and does *not* ask about pricing but wants to come into your studio to view your work and meet with you, chances are she is serious about professional wedding photography. Her main concern is not price but quality—and your reputation. These are the clients you want.

Consultation. When the client comes into the studio, show them two or three completed albums. We use flush-mounted albums from Capri Albums from New York for our studio samples. They are very upscale and beautiful. Point out what makes your photography worth your higher prices. Photo examples of excellent posing and natural lighting should be present in your studio sample albums. After all, if the client can't *see* what makes your pictures different from a lower-cost studio's images, then there is no reason for them to *pay* the difference.

This beautiful bride was photographed on her glassed-in porch on a rainy day. Note how proper placement of the bride in relationship to the direction of light creates a beautiful lighting ratio on her face. Note that the shadow side of her face is closest to the camera. This type of lighting is very flattering.

Since all brides are different, find out what type of photography the client likes best and focus on the work that suits her tastes.

If the bride decides she wants to book you, be certain that she fully understands all of your payment procedures and policies. Try to keep it all very simple. Clients get uneasy about any transaction they don't fully understand. On a related note, be sure to take notes on anything that *you* will need to know on the wedding day. Issues such as divorced or deceased parents are things that you should be aware of ahead of time.

We require approximately 15 to 20 percent of the total price as a deposit or retainer to hold the date. Any refunds are handled on an individual basis depending upon the circumstances, and I can honestly say that, at our studio, cancellations are rare.

About a week prior to the wedding we call the bride to once more confirm everything. We remind her of the times that have been agreed upon and emphasize to her that being on time will make everything less stressful. The key to a good day with a bride is giving her as much information as you can. You know from experience about how long everything will take and how to make things run smoothly.

The Wedding Day. I photograph weddings with an assistant. You certainly can do it on your own, but why knock yourself out? My assistant works on the candid photos while I concentrate on the posed ones. It's a good combination and a good way to offer a better product.

Before the Ceremony. On the day of the wedding, my assistant and I arrive approximately fifteen minutes before the agreed-upon time, dressed in black tuxedos. The vehicle that we arrive in has been cleaned, and we look totally professional. Image is everything!

When we arrive at our first destination of the day, I look for areas where I can photograph the bride with window light. Use your flash as

Having an assistant at weddings will make things run more smoothly. Although you can photograph a wedding alone, having an assistant work with you is advisable.

little as possible: this will separate your work from the competition.

The Ceremony. During the ceremony, having an assistant gives you the opportunity to photograph the wedding from different areas. We have some beautiful photographs where the bride and groom are coming down the aisle after the ceremony—I shoot images from their level, and my assistant takes the same shots from up in the balcony. I just don't think it's possible to cover a wedding as well with one person as you can with two.

After the Ceremony. After the ceremony, we generally do the posed photographs of the family members. I find it best to start with the grandparents first, then parents and family members, and then any other special groups the bride and groom may want photographed. We finish this sequence with photographs of the bride and groom. Keeping things moving and being quick is the key; depending on the size of the wedding party, you should be able to do all of the groups and bride and groom shots in about forty-five minutes.

After the ceremony, many couples want to go to an outdoor location for more photographs. To make your outdoor photographs look their very best, be sure to use a long lens so that the backgrounds will be out of focus. This will make the bride and groom really stand out.

The Reception. Once you get to the reception, most of the hard work is behind you. Most receptions last at least three to four hours, and we usually stay most of the evening, since our pricing is set up to cover a ten- to twelve-hour day. Many studios charge by the amount of time the bride has booked. Although there is certainly nothing wrong with

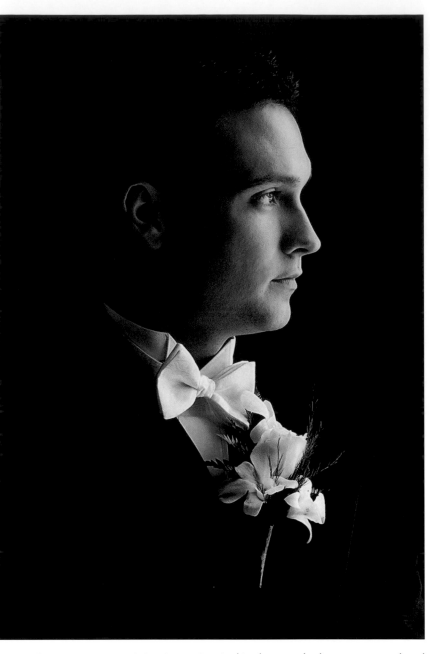

In this photograph, the groom was placed near a window, and the natural light created a pleasing ratio on his face. Use natural lighting as much as possible when photographing weddings.

that practice, I have never charged that way; I think it would just cause problems—after all, anyone who has done their fair share of weddings knows that things usually do not go as planned time-wise. I don't want to have to approach the bride during the reception and remind her that she only booked us for the eight-hour coverage, so we will be leaving shortly.

I know of one photographer who stays for only the first thirty minutes of the reception. Of course, the bride knows all of this beforehand, and the photographer arranges for her to get everything over in the first thirty minutes—the toast, dancing with dad, cutting the cake, you name it—just so he can go home early! If it's working for him, great. I know one thing for sure: if my daughter went shopping for a wedding photographer and he told her he would be leaving the reception after thirty minutes, he wouldn't be hired.

Lens Selection. I recommend that you have available several different types of lenses to use during the wedding day. Use lenses that the amateurs at the wedding probably don't own; using a very long lens or a fisheye lens will make your photographs look different than all the rest. You do not want your pictures to look like they were taken by the guests. Creating unique photographs will pay dividends later when the bride orders her final album.

One way that we ensure that our images stand out from the rest is by using double lighting. Double lighting requires two flashes, a radio transmitter, radio receiver, and a light stand (or better still, an assistant).

No matter how carefully things are scheduled, weddings rarely go exactly as planned. If you want to create top-notch images, you'll need to remain flexible and be ready to take the opportunities you get.

To create this look, simply hook your on-camera flash up to a radio flash transmitter. Your second flash, which can be up to one hundred feet away, should be wired to the radio flash receiver. When you push the button on your camera and your transmitter is turned on it fires the flash on the camera and sends a signal to the receiver, and the second flash goes off as well. Having as assistant hold the light and move it around is better than putting it on a light stand. You can create some really neat effects using this system. You can back light a couple at a reception or light a large hall, which can be difficult with just one flash. You control both lights from the camera and can fire just one or both, simultaneously. Most major camera stores carry the equipment needed to double light. Be aware that achieving good results will take practice and a thorough understanding of your flash equipment. One final tip: be sure that both of your flash units have the same output. This will make things much simpler.

After the Wedding Day. Good service is just as important as good photography in the wedding business. Regardless of how you are showing your images to the couple, they should have their proofs or CD in

Creative techniques, like the infrared photography shown here, can help set your studio apart from the competition.

no more than three weeks. Once the order is placed, be sure to deliver it within twelve weeks.

Pricing. Wedding photography can be very lucrative if it's properly priced. Unfortunately, the wedding industry is filled with photographers who give us all a bad name. If you are going to be a serious player, you need to learn as much as you possibly can about posing, lighting, and customer service. To get serious money, everything must be top notch in your operation. You want people to be proud when they say, almost bragging, "Williams Photography is photographing my wedding!" Building a reputation takes time, but it will be well worth it. Whatever pricing strategy you decide on, it's a good idea to have a statement on your wedding contracts noting that your current prices are not good forever. I have had wedding clients come in five years after their wedding to order pictures.

In my experience, you'll have more problems with wedding clients than any other demographic—and most of the time, it's the parents (who were never in the studio before the wedding to discuss prices, procedures, and delivery times) who cause the problems. If the bride and groom both have divorced parents, you can actually be dealing with four, five, or even *six* individuals, each with their opinions on what you should be charging! Be sure to have everything in writing.

◼ FAMILIES

Photographing families is the most profitable aspect of our business. Unfortunately, we just do not get enough calls to offer nothing but family portraits. Church directory companies can make it difficult for a studio to compete when it comes to family portraiture (see below). For most people, price is the main motivator in choosing a family photographer, and for this reason, a lot of family photography is done by church directory companies. However, there *are* clients who value quality over price and will pay for a premium family portrait.

To stay competitive in this area, be sure to offer services that clients can't get from church directory companies, such as photography sessions in the clients' home. With this type of session, you can show your digital images using a laptop and projector immediately following the shoot, when excitement over the session is still high. Remember, to sell big, you must show big. You will have an easier time selling a large print when you project a 20 x 24-inch over their fireplace immediately following the session than you would if you were to show a 4 x 5-inch print two weeks later in the studio.

To get serious money, everything must be top notch in your operation.

Consultations. When a client calls our studio to book us for a family portrait, we suggest that they come in for a consultation. We have brochures that we give to the family members to ensure they will be dressed properly for their session. We discuss with them the different print sizes and finishes that we offer, and we suggest they locate an area in their home where they think they will want to display their family portrait. We also ask them to consider the type of frame they may want to purchase. Making this effort before the session enhances the clients' interest and gets them excited about how good the photograph is going to look when it's displayed in their home.

Basic Goals. On the day of the session, we will do at least two different poses of the entire family group. The main thing to shoot for is getting the right expression on *everyone's* face. It's also a good idea to break the family down into smaller groups. Photographs of just mom and dad and just the children will usually increase your sales.

Presentation. In my experience, projection is definitely the best way to present your family portraits. With the new video projectors today, you don't even need a large, darkened room to create an impressive show. These units project a very bright image, even in a lighted room. By projecting, you can quickly show your clients different sized photographs. Start the projection process by showing very large wall portraits. Most of the time the client will say that the image is too large. When you come down a size or two, though, you are still showing a 24 x 30- or at least a 20 x 24-inch print. Showing the client a 4 x 5-inch paper proof and trying to sell a larger photograph is very difficult. Projecting your images all but guarantees the sale of a larger print.

Keep in mind that families investing in portraiture are spending discretionary income. Therefore, to maximize the sale, everything from the phone call down to the delivery of the final product should be top notch. Your main competition for this kind of spending is not other photography studios but other businesses selling luxury items that none of us really *need*. Look around and take notice. Most businesses selling luxury items are polished, well-run operations. Jewelry stores, luxury car dealerships, and hotels are excellent examples. In these businesses, you'll see that everything is geared toward the luxury buyer. Photography is certainly no different.

Church Directory Companies. Church directory companies operate much like high-volume underclass school picture companies. They go from town to town and photograph families in churches for free (the church probably gets a kickback).

> We also ask them to consider the type of frame they may want to purchase.

These directories usually feature a photograph of each family grouping, along with name and address of each group. Also usually included are some photos of the church and a little written history. The bet is you will be so happy with the family portraits that you will buy photographs for yourself and all your family members.

Generally, the companies set up in two rooms and photograph families by appointment. Once the clients are photographed in the "camera room," they move into the sales room. The salespeople that work for these companies are usually commissioned and have their presentation down pat.

Needless to say, this type of photography is slightly better than nothing. The lighting and posing is poor, there's no retouching, and the pictures are cheap (and cheap looking). These companies operate on volume and do the selling right after the session while the excitement over the session is still at its peak. For most families, this will be the only family portrait they will ever have.

◼ PRODUCTS

Product photography is a very specialized photography. Although we do not advertise for our product photography services, we are occasionally called to photograph a building, product, or to take photographs for insurance claims. I recommend that you meet with the interested party before committing to do this type of work to find out exactly what it is that they want. Be sure to get a portion of your fees up front.

Family portraits are very profitable when done properly. Posing is critical with large groups. Study the placement of each person and the placement of their hands.

9. MARKETING IS KEY

*I*deally, about 10 percent of your gross dollars should go into your marketing campaign. Knowing *where* to put your hard-earned advertising money is, however, a real challenge. We have tried about every type of advertising you can think of, and I learned the hard way that anyone who sells advertising will tell you anything to get you to spend money with them. We have done radio and movie theater ads; mall displays; all sorts of mailings; video shows at high schools; yearbook ads; football, soccer, and basketball program ads; yellow pages ads; phone-book cover ads; website ads; and the list goes on. I even had a salesman try to sell us ad space on grocery carts!

In this chapter, we'll first look at some basic components of advertising, then we'll delve into some of the advertising strategies our studio uses to reach our various client demographics.

Knowing where to put your hard-earned advertising money is a real challenge.

■ BASIC MARKETING STRATEGIES

Plan Ahead. Planning your marketing in January for the year ahead will pay big dividends if done properly.

Get a large yearly planner from an office supply store. Mark on the calendar all the start dates for your major promotions. Dates like Valentine's Day, Easter, promotions for weddings, high-school seniors, etc., should all be marked. Determine the dates that you want your marketing materials to be received by your target market. Be sure to factor in things like production print times, assembly, delivery of the mailers, etc., when establishing your advertising schedule. I

recommend that you give yourself at least a couple of months to work on your promotion and for your printing company to get it printed.

In our studio, if a client calls two or three days or so after the end of a promotion, we won't turn away their business. We'll say something like, "The promotion you are calling about ended last Friday, but but if you can make your appointment within the next week or so, we will gladly extend the offer for you." Remember, the whole point of running a promotion is to get clients through your door, not to turn someone away because they happened to call a few days late.

Spend the Time and Money. Good advertising does not just happen. It takes a lot of time and capital—and it all goes back to what type of clients you want to attract. The advertising materials your client receives send a powerful message as to what type of studio you are. Be sure all of your promotional materials look and feel expensive. Look at brochures from other types of businesses for ideas on paper stock and layout. You only have five or ten seconds to create a positive reaction to an offer received in the mail.

> Advertising materials send a message as to what type of studio you are.

I would suggest spending at least one day a week working on your marketing. I have visited many studios, and the ones that are really successful all have one thing in common: they advertise frequently. Good marketing is not an expense, it's an investment.

■ DIRECT MAIL

Direct mail is by far the most effective advertising we do. Of course, it is also the most work and the most expensive—but I can honestly say that anytime we mail out a promotional piece we make money from it. The time of year and your promotional offer will determine your response rate.

Bulk-Mail Permit. Direct mail is usually sent out third class via a bulk-rate permit. You can buy your own permit from the post office or take your mail pieces to a bulk-rate center and use theirs. The amount of mailing you do will determine if you should have your own permit.

I recommend taking your bulk mail to a bulk-mailing center for processing. We used to do all of the work ourselves, putting the labels on the envelopes, stuffing the envelopes, etc., but found it was much more cost effective just to take it to the mailing house and have them do all of the work. Be sure to give them enough time to prepare your mailing—especially if you have a time-sensitive piece. When something is sent bulk mail it can take up to seven days for the recipient to receive it (only first-class mail receives top priority for delivery).

Carefully controlled lighting on the subject's face creates a dramatic photograph. The approximate 4:1 lighting ratio on the face creates impact that is not achieved with flat lighting.

Response Rate. The industry standard for direct mail response is about 2 percent. If you send out three-thousand pieces and get a response from about sixty clients, your direct-mail campaign was a success. Don't waste your time sending out only three or four hundred pieces; in my opinion, at least two-thousand pieces are needed for an effective campaign.

Add a Deadline. Be sure to have some sort of a deadline on your mailer. This will create a sense of urgency and encourage the recipient to act quickly on your offer.

◼ MALL DISPLAYS

We have had a display at the major mall in our area for over seven years. Although it is fairly expensive, we find it worth the cost—in fact, many high-school seniors make it a point to ask me if they are going to be chosen to appear in the mall display! Our display is not that large, but it is well lit and situated in a very good spot.

Dealing with malls can be frustrating. Your first step should be to talk to the marketing manager. Have some sample photographs with you and a photograph of your proposed display. The mall is likely to be very fussy as to the size, height, etc., of the unit. You will also be required to have liability insurance.

A mall display can provide you with excellent exposure and create excitement among your clients. Be sure to obtain a signed model release from everyone whose image you put in your display. Be sure to include

literature pockets at the bottom of the display and keep the pictures fresh. We try to change our photographs about every six weeks, so even frequent shoppers are always seeing something new when they pass it.

◼ YELLOW PAGES

There are many more forms of advertising that *do not* work than *do*. In my opinion, one of the most ineffective forms of advertising for a photography business is the yellow pages. I think just about every new studio gets sucked into the big lie that the yellow pages is the end-all-and-be-all in advertising. I've heard it all before—just place a large color ad in the local yellow pages, and your phone will ring off the hook! The salesman will tell you that the bigger the ad, the more the phone will ring. Take it from someone who has been there, *don't believe it!* Here is an absolute fact: you can always tell the newest photographers in town by the size of their yellow page ad. It is always the biggest one in the photography section—they don't know yet that they are wasting their money! Every time I travel out of town, I always look in the yellow pages for well-known photographers that I know are in that area and *rarely* do I see anything larger than just a single-line listing. My experience with the yellow pages is that it attracts shoppers whose concern is price—and nothing else. Do not waste your money on a large ad in the yellow pages.

◼ WORD OF MOUTH

The quality of service and product you provide, and the professionalism of your employees, will determine the type of client you will attract—and the number of calls you get for service. The fact is, photography is very much a "people business." If a high-school senior was not happy with their photographs or the service they received from you, chances are his older sister won't be calling you to photograph her upcoming wedding. Of course, the same rule applies to sports league or family portraits too.

Now, in the first part of this chapter, we have looked at some basic marketing strategies. Next, we'll take a closer look at the types of marketing you should use to draw clients from specific markets.

◼ SENIOR PORTRAITS

Mailing Lists. Most of the mailers we send out are for high-school seniors. Generally, we send seven or eight different promotional mailers a year.

Generally, we send seven or eight different promotional mailers a year.

Wall Portrait Packages

Wall Portrait Size	Economy Finish	Deluxe Finish	Canvas Finish	Hand-Painted Brush Stroke On Canvas
30 x 40	$879.00	$969.00	$1110.00	$1359.00
24 x 30	$739.00	$785.00	$910.00	$1110.00
20 x 24	$629.00	$659.00	$759.00	$905.00
16 x 20	$479.00	$519.00	$605.00	$759.00
11 x 14	$399.00	$429.00	$469.00	$550.00

All wall portrait packages include:
2-8 x 10's, 2-5 x 7's, and 40 Wallets
PLUS the wall portrait size & finish of your choice.
Choose From 3 Poses
Wall portrait frames available at discount prices.

Packages Without Wall Portrait

Package A: *Choose from 3 poses*
• 3 - 8 x 10 • 4 - 5 x 7's • 47 - Wallets

Economy Finish	*Deluxe Finish*
$515.00	**$569.00**

Package B: *Choose from 2 poses*
• 1 - 8 x 10 • 4 - 5 x 7's • 31 Wallets

Economy Finish	*Deluxe Finish*
$359.00	**$399.00**

Package C: *1 Pose only*
• 1 - 8 x 10 • 2 - 5 x 7's • 8 Wallets

Economy Finish	*Deluxe Finish*
$189.00	**$215.00**

4 Print Finishes to Choose From...

Hand Painted Brush Stroke on Canvas - Photograph is placed on canvas and mounted to 1/8" masonite, then a hand-painted brush stroke is applied which gives your photograph the look of a beautiful hand-painted portrait. Photograph is then sprayed with a protective lacquer finish.

Canvas - Photographs (11 x 14 and larger) are placed on canvas which is then mounted on 1/8" mount board and sprayed with a protective lacquer finish.

Deluxe - Photographs are given the look of canvas and sprayed with a protective lacquer finish.

Economy - Photographs (11 x 14 and larger) are mounted on 1/8" mount board and sprayed with a protective lacquer finish.

• **FREE** yearbook picture with any package.
 (Yearbook photo without package order - $49.00)
• **FREE** 8 print folio on any order more than $725.00
• **FREE** Senior yearbook album on any order more than $950.00
• 5 x 7's in a package are sold in sets of 2 - from same pose.
• Additional poses available for $25.00 each pose.
• Retouching includes the blending of skin blemishes and the softening of lines under the eyes. Other corrections, such as eyeglass glare and hair out of place, require extra artwork and are charged for on a per print basis.
 Minimum charge - $30.00
• Since eyeglasses sometimes cause glare and distortion in photographs, we recommend that you contact your optometrist who will furnish you with a pair of frames that look just like yours.
• Please allow 6 weeks for delivery of finished prints.

Photography trade magazines such as *Rangefinder, Professional Photographer* (published by PPA), and *Studio Photography* advertise the names of name-and-address companies that photographers can call on to generate contact information for a given client demographic. We have found that while the lists we used from these companies were 85 to 90 percent accurate a few years back, the rate has declined over the past several years. In 2004, we purchased a list of about 3500 names and addresses that proved to be only about 38 percent accurate! Of course, when we received the list from the company, we had no idea how bad it was. It wasn't until a few months later when we got the lists for area high schools from our senior models (our name for what many studios call senior ambassadors) and cross-checked the two that we discovered how poor the purchased list was. (And I might add that there has been no reduction in the prices charged, despite the fact that the lists are so poor!)

ABOVE AND FACING PAGE—Our Portrait Investment brochure makes it easy for clients to determine the best products and packages for their needs.

Wallet Size Photos
(1 pose only)

144 wallets	$169.00
120 wallets	$152.00
96 wallets	$135.00
72 wallets	$115.00
48 wallets	$ 82.50
32 wallets	$ 63.50
24 wallets	$ 51.00
16 wallets	$ 34.00
8 wallets	$ 22.00

- *Name and year imprinted on wallets in gold, silver or white - $17.00 per pose*

Additional Photographs

Portrait Size	Economy Finish	Deluxe Finish	Canvas Finish	Hand-Painted Brush Stroke On Canvas
30 x 40	$665.00	$725.00	$910.00	$1270.00
24 x 30	$515.00	$579.00	$785.00	$1080.00
20 x 24	$405.00	$459.00	$600.00	$785.00
16 x 20	$245.00	$285.00	$395.00	$545.00
11 x 14	$155.00	$185.00	$275.00	$365.00
8 x 10	$75.00	$90.00	Not Available	
5 x 7	$65.00	$79.00	Not Available	
4 x 5	$54.00	$59.00	Not Available	

What About Purchasing A Folio?

1. Previews are not for sale without a minimum order of $189.00

2. Deluxe folios are included with your previews.

3. As your order size increases the cost of the previews decreases.

Order Size	6 Print Folio	8 Print Folio	12 Print Folio
$189.00 - $365.00	$85.00	$105.00	$120.00
$366.00 - $545.00	$75.00	$85.00	$109.00
$546.00 - $725.00	$60.00	$75.00	$90.00
over $725.00	8 PRINT FOLIO FREE		$25.00

Terms & Conditions

Deposit required on previews removed from studio.

All photographs taken by Williams Photography are subject to copyright laws. Any individual who so violates the law by unlawfully duplicating any part of an order will be subject to prosecution.

ALL BUSINESS BY APPOINTMENT ONLY

MasterCard • VISA • Discover • American Express Accepted

Ultimately, this means that 60 percent of our mailers went out to people who probably didn't need our services! Simply put, relying on a list purchased from a name-and-address company is not the best way to acquire your mailing list. Although it's a challenge, you will have to get the list from members of the junior class or from the model-search promotion (see page 110). Knowing a secretary or a student aid who works in the high-school office can be beneficial too.

Mailing Schedule. Be sure to give yourself about eight weeks' lead time for your promotions. This will give you time to design the brochure and get it ready for mailing. The first mailing of the calendar year offers a low session fee for seniors who have not yet had their pictures taken, or those who had them taken elsewhere and were not happy with the results. In our area, most high schools require that yearbook pictures be turned in to the school by the end of the *calendar year*, not the end of the school year. Of course, this means that anyone getting

their pictures taken in January has missed the yearbook deadline and will not be in the yearbook. Most seniors have already been photographed, so this is one of our least effective promotions—but since the first three months of the year are the off season, it is still a worthwhile promotion.

Great Model Search. Toward the end of January, we mail out our next direct-mail piece. The "Great Model Search 2006" (or whatever year it happens to be) mailer goes out to high-school juniors. To get their names, we buy a single mailing list, because we know from past experience that the list will be only *about* 40 percent accurate.

In the mailer, we outline our senior model program, a "promotion" that has clear benefits for the students and the studio. Here's how it works: Interested students respond to the mailer by calling the studio and making an appointment to learn more about the program. You don't have to call them and ask if they want to work for your studio, and this solves two problems. First, trying to catch a high-school junior after school on the telephone is a crap shoot at best. Second, when you call, many parents will think you are a telemarketer, and they really won't want to hear what you have to say. I've done it both ways and, believe me when I tell you, having the students call you is best.

When the students call, we briefly explain to them what the program is and what is expected of them. In a nutshell, the students get a free session and are expected to provide the names and addresses of their classmates, plus drum up business by showing off their pictures and handing out marketing materials. We tell them that this is no giveaway program—they will be expected to produce results and will be well rewarded. If they are still interested, we set up a meeting with them and one of their parents at the studio to further explain everything. It is very important that you have a parent come to this meeting with the student. I would suggest having no more than three students and parents attend your meeting at one time.

During the meeting, we explain in detail what is expected of them and the rewards they will receive. Everything we tell them is also provided in writing in a senior model handbook that they receive. Most problems occur due to misinformation, so your handbook should be clearly worded to minimize any misunderstandings. After the presentation, we ask each student if they would like to sign up—and most of the students who attend the meeting do sign on to become a senior model.

After the meeting, we set up a time for their photography session and remind them, again, that we need names and addresses of their classmates. When they come in for their photography session, we give

After the presentation, we ask each student if they would like to sign up.

YOU'VE WAITED A LONG TIME FOR YOUR SENIOR PICTURES
CHOOSE YOUR PHOTOGRAPHER WITH CARE

Bring this certificate the day of your session and receive 75% OFF the session of your choice ($64 value) & 16 FREE wallets ($39 value) when you place your order.
Total Savings $103!!

The Senior Model at your school is: _____

James
Williams Photography

PPA CERTIFIED
Professional Photographers of America

1101 Prentice Road • Warren, OH 44483
Phone: (330) 847-0927 • 1 800-320-9005
www.jwilliamsphoto.com

- -

Please send me information about Senior Pictures.

Name _____

Address _____

City, State, Zip Code _____

School _____

Phone Number _____

James
Williams Photography

1101 Prentice Road
Warren, Ohio 44481

Our senior models give their friends promotional cards entitling them to significant discounts on their sessions.

them a lot of variety. About a week to ten days after their photo shoot, we set up an appointment for them to come in and pick up the folio and marketing materials that they will be passing out at school.

There are three main benefits to running this program:

1. **Early sessions for the studio.** Although the models get a free session, they pay a hefty deposit to take their photographs out of the studio. This creates cash flow in late winter and early spring—typically a slow time of the year for studios. One word of caution here: you will find that about 10 percent of your models will not come in and put a deposit down on their model folio. Last year we had about thirty models, and three of them never came in to get their final folio pictures. They responded to the model flyer, attended the meeting with their parents, came in for the photo session, and came in to look at their session photos and pick out the photographs for the folio. When it came time to fork over the cash, you guessed it—they were no shows. If you look at our overall results, twenty-seven models times a $350 deposit, you'll have to agree that we had a very good return on the promotion.

2. **The models show their folio to all of their friends.** We have our senior models give their friends promotional cards that entitle students to a discount-price photo session and sixteen free wallets. For each senior who comes in with the card, the model receives a $20.00 credit toward their final order. Everyone wins. The studio gets new clients, the models receive a $20.00 credit for each card turned in with their name on it, and the senior turning in the card

gets 75 percent off their session fee, plus sixteen free wallets when they place their final order.

Our direct-mail pieces showcase a variety of images.

3. **The new models obtain the names and addresses of their class-mates.** This is probably the most important function of the new models each year. Without accurate contact information, it's difficult to run an affective advertising campaign.

As I mentioned briefly earlier, I suggest you obtain a deposit before you part with any images. Many studios let the senior models take the pictures out of the studio with no type of deposit. I can tell you for certain that, if you do, some students will never return them. I don't care what kind of incentives you have, some people just have no respect for your product. I hate to sound negative, but that's the way it is. We require our models to pay a $350 deposit when they take out their promotional photographs. This is fully understood during the meeting they attend. I suspect that may be why a few people back out of the program after they attend the meeting. When the models return their proofs later in the year, however, the full $350 deposit goes toward their purchase—but if we never see them again, at least we have some money from them. Don't feel bad if you have a few models never return their pictures.

In early May, we send out a twelve-page, full-color brochure to prospective senior-portrait clients.

Anyone using models or ambassadors is going to have students not return the folio. This is why it is important to get a hefty deposit from each model beforehand.

Twelve-Hour Sale. Another promotion that works well is a twelve-hour sale. Although there are other studios using this promotion in our area, it is still a very effective way to book a lot of seniors in one day. The one-day-only sale creates a sense of urgency for the client to call on the sale day. I would suggest mailing it in early- to mid-April for a later April sale date. During this half-off sale, we require all clients to prepay for their session. We will take their credit card payment over the phone or give them three to four days to send in their payment. We simply explain that there are a limited number of appointments available and their advance payment guarantees their appointment time.

Discounted Session Fees. In early May, we send out an 8½x11-inch, twelve-page, full-color brochure with an insert in it touting a discounted-session-fee promotion that runs about three weeks. We always make a point in our mailings to create a sense of urgency. We say, "There are a limited number of appointments available, so *call now!*" About two weeks later, we send a small postcard as a follow-up, extending the offer for another week. By the end of this promotion, we are into the summer months, which are always very busy for our studio.

By starting your promotions early in the year you have given yourself a much better chance of filling up the summer with sessions. Frequent mailing is almost a must if you want to do more than two or three hundred senior sessions a season.

High-School Newspapers and Yearbooks. Advertising in the local high-school yearbooks is something you are almost going to *have* to do if you are photographing high-school seniors. Placing an ad in the yearbook is really not an effective form of advertising, though. I consider it a donation to the high school. I would suggest getting at least a half-page ad and featuring pictures of seniors from the school who came to you for their portraits. Students love to have their pictures in the yearbook as many times as possible. Another idea for your ad is to have testimonials from the students under their pictures.

Advertising in high-school newspapers, usually monthly publications, works fairly well. We have successfully run ads with pictures and testimonials in some of our area high-school papers. Every year we are also asked to run ads in soccer, football, and basketball programs. Like the yearbook ad, this is seen more as a donation. We always agree to run the ads, but we really don't expect any return on our investment.

> We make a point in our mailings to create a sense of urgency.

To attract the high-end bride, you will have to put your advertising dollars in the right place.

■ WEDDING PHOTOGRAPHY

As you probably know by now, we operate a higher-end studio and emphasize service and quality. Where you market and the personality of your studio will determine, to a large degree, the type of bridal clientele you are going to attract. The fact is, there are weddings every week at fire halls and country clubs, but there are whole lot more fire-hall weddings than country-club weddings. To attract the high-end bride, you will have to put your advertising dollars in the right place. Advertising in regional bridal magazines, constructing mall displays, and attending bridal shows are all effective means to attracting higher-end wedding couples. A word of caution: If you are going to participate in a bridal show, be careful which ones you choose. Those bridal shows that charge admission and are held at hotels are usually a good bet. I made the mistake one year of participating in a bridal show in a mall. There was no admission fee, which meant anyone who wanted to kill some time meandered through the show. I did book one bride at that show, but a lot of the girls looking at our samples were just not going to have a big

James Williams Photography

certified professional photographer

1101 Prentice Rd
Warren, Ohio 44481

330 847-0927
1-800-920-3005
www.JWilliamsPhoto.com

Wedding Photography Investment Brochure

Professional Photographers of America

Complete All Day Coverage of your wedding and reception
$3000.00

The entire $3000.00 fee applies to your photographs and album. If you like, we will design your album for you.

A few words about our photographer:

• Williams is a certified professional photographer at both the state and national level. Williams passed a written exam and entered photographs to a national and state panel of judges for review and approval to become certified. Less than 3% of all imaging professionals have completed and maintained the requirements for certification.

• Williams is a Wedding Portrait Photographers International Master Photographer.

• Williams is one of only 40 members of the prestigious Ohio Society of Professional Photographers. This organization consists of some of the most talented photographers from across the state. Membership is by invitation only.

• Williams has served as president of the Society of Northern Ohio Professional Photographers, a professional photography organization based out of Cleveland, Ohio.

• Williams teaches photography and is a popular guest lecturer in the mid-west. Currently, Williams is writing a book on photography, due out in book stores early next year.

• Williams Photography has been in business more than 20 years. Be assured whenever you call our studio you will be dealing with professionals who are dedicated to providing you with the highest level of professionalism and expertise available.

Photographs available in 3 different finishes.

Deluxe Texture Finish

4x5's or 5x5's	5x7's	8x10's	1/2 pan	full pan
$28	$30	$36	$105	$200

Texture Finish

4x5's or 5x5's	5x7's	8x10's	1/2 pan	full pan
$24	$28	$34	$90	$175

Standard Finish

4x5's or 5x5's	5x7's	8x10's	1/2 pan	full pan
$20	$25	$32	$80	$160

Wall Portraits

Print Size	Hand-Painted Brush Stroke On Canvas	Canvas Finish	Deluxe Finish
11x14	$300	$225	$150
16x20	$450	$325	$235
20x24	$650	$500	$375
24x30	$875	$650	$475
30x40	$1050	$750	$600

Wedding Albums

Finest Hand Bound Leather Album

All leather and hand crafted. All of your photographs receive our deluxe/texture finish, then they are mounted to each page by hand. You will be proud to show this all leather top-of-the line wedding album to your family and friends. $725.00

Deluxe Album

This deluxe vinyl album has the look and feel of leather. A very upscale album. Available in a variety of colors. $595.00

Standard Album

A lovely album for your wedding memories. Although not book bound, this album is a beautiful addition to your photographs. $350.00

Economy Album

A Vinyl Album for your wedding photographs. $275.00

Parent Albums $210.00

please note: prices are for album covers and pages only, photographs are not included.

FACING PAGE—Our Wedding Investment brochure presents our prices along with a list of reasons why our services are worth investing in.

fancy wedding. Brides having their reception at the local fire hall or VFW hall will not spend $5000.00 dollars on wedding photography, regardless of how good your pictures might look. In fact, the entire wedding probably isn't going to cost that much! There are a vast number of photographers who will photograph a wedding for $500.00 or less. Do not waste your money printing coupons. Brides with discretionary income are not into clipping coupons. Many of these brides are spending their parents' money and really aren't all that concerned with saving a few bucks. Their thinking is, this is my big day, and I want the very best.

Once you begin working with your desired client type, and provide the type of product and service a high-end client demands, word of mouth will be your best source of advertising.

■ SPORTS LEAGUE PHOTOGRAPHY

All of our league jobs have resulted from interacting with someone who had come to the studio for another type of photography—and just happened to be president of a soccer league, or something to that effect. I know I probably sound like a broken record, but the fact is, when a studio is doing everything right, a lot things just fall into place.

You won't acquire a sports league contract through direct-mail advertising, so if you haven't made the right contacts in your studio, try these ideas to increase your chances for scoring a sports league contract:

- If you have a mall display, put up some samples of your league work. There's always a chance that a league president in need of a new photographer will see it and make contact.
- Read your local newspapers daily. Usually there are listings in the local paper telling the parents where sign-ups for baseball, soccer, football, etc., are held. Prepare a first-class presentation packet with photo samples, prices, etc., and on sign-up day, give it to the president of the league. If he had a lot of problems with last year's photographer, he may be looking for a new studio.

Remember, the last thing these volunteers want is problems from the parents. If no one is complaining about the pictures, chances are, you won't be hired. It doesn't take much to make these people happy in the photo department.

Many people who pay $15.00 to $20.00 for a memory mate package for their child would never think of spending over $1,000.00 on a

family portrait. They simply do not have the discretionary income that some folks will spend on higher-end photo packages. You have to have an entirely different mind-set dealing with leagues than you do with clients in the studio spending thousands of dollars on a portrait order. These clients are looking for decent images with good expressions—not all of the bells and whistles you might offer to bigger-budget clients.

Family portraits are always profitable. These photographs were done inside the clients' home, outside the studio, and in the studio.

◘ FAMILY PORTRAITURE

Most of our family portrait business comes from the high-school seniors we photograph. We offer a free family portrait certificate to all our high-school senior clients when they pick up their final order and place a follow-up call to th client to remind them of the free session a few months later. To be perfectly honest, only five to ten clients take advantage of the certificate each year.

We also have family portraits displayed in the studio and include family portraits in our mall display to create interest. You can also use

direct mail to draw new family portrait clients; just purchase a mailing list (see page 108) from an address broker and qualify it by income level. I would suggest sending the mailers to families making more than $50,000.00 a year. The fall of the year is a good time to send out a promotion for family portraits. Chances are, you will receive some calls to come into clients' homes to create holiday portraits.

Family Portrait Investment

Hand-Painted Brush Stroke on Canvas - *Photograph is place on canvas and mounted to 1/8" masonite, then a hand-painted brush stroke is applied which gives your photograph a look of a beautiful hand-painted portrait. Photograph is then sprayed with a protective lacquer finish.*

30 x 40	$1270.00	24 x 30	$1080.00
20 x 24	$ 785.00	16 x 20	$ 545.00
11 x 14	$ 365.00		

Canvas Print - *Photograph is placed on canvas which is then mounted on 1/8" mount board. Photograph is then sprayed with a protective lacquer finish.*

30 x 40	$910.00	24 x 30	$785.00
20 x 24	$600.00	16 x 20	$395.00
11 x 14	$275.00		

Deluxe Print - *Photograph is given the look of canvas and sprayed with a protective lacquer finish.*

30 x 40	$725.00	24 x 30	$579.00
20 x 24	$459.00	16 x 20	$285.00
11 x 14	$185.00		

Standard Print - *Photograph is mounted on 1/8" mount board and is sprayed with a protective lacquer finish.*

30 x 40	$665.00	24 x 30	$515.00
20 x 24	$405.00	16 x 20	$245.00
11 x 14	$155.00		

Large Selection of Beautiful Wood Frames Available!

Small Prints

	Economy	Deluxe
8 x 10's	$75.00	$90.00
5 x 7's	$65.00	$79.00
4 x 5's	$54.00	$59.00

Wallet Size Photos

16 wallets	$34.00
8 wallets	$22.00

Family Portrait Session Fees

in studio - $85.00
in your home - $100.00

Terms & Conditions

- All finished prints have been analyzed & color corrected to ensure a beautiful portrait.

- Retouching includes the blending of skin blemishes and the softening of lines under eyes. Other corrections, such as eye glass glare and hair out of place, require extra artwork and are charged for on a per print basis. Minimum charge - $30.00.

- Since eyeglasses sometimes cause glare and distortion in photographs, we recommend that you contact your optometrist who will furnish you with a pair of frames that look just like yours.

- Please allow 6 weeks for delivery of finished prints.

- All photographs taken by Williams Photography are subject to copy right laws. Any individual who so violates the law by unlawfully duplicating any part of an order will be subject to prosecution.

ABOVE LEFT AND RIGHT—Our Family Portrait Investment brochure details the available products and the terms and conditions of the sale. **RIGHT**—All of our senior portrait clients receive coupons for a free family portrait session.

James **Williams Photography**
Family Portrait Session

This certificate entitles you
To one Family Portrait session
FREE! - Save $85.00

Call (330) 847-0927 to schedule your session.

Certificate expires _____

10. NETWORKING

Anyone who wants to fast-forward their photography career needs to join their local and state photography affiliations. Most of the state-run organizations have several programs and one major convention a year, while the local groups meet once a month. Attending the state and national conventions, such as the Professional Photographers of America (PPA) and Wedding Portrait Photographers International (WPPI) conventions, is always fun. These include a large trade show and many good speakers. You will leave these shows all charged up and ready to try out the new tools you have purchased or tricks you have learned.

Joining a local affiliate of PPA will give you the opportunity to hear speakers monthly and network with people who have been in the business for years. Although you may have to drive a distance, I think you will find the time well spent. The closest affiliate for me is the Society of Northern Ohio of Professional Photographers (SONOPP), based in Cleveland, Ohio. It is about a one-hour drive from where I am located in Warren, Ohio. Joining SONOPP has definitely impacted my business in a very positive way. The state of Ohio and the Cleveland area in particular have some extremely talented photographers with successful businesses. There is just no way you can learn everything yourself. The more you get involved, the more you will benefit.

Photography is always changing, and keeping current is essential if you want to continue or improve your success. Attending week-long schools or even two- or three-day seminars will pay big divi-

Keeping current is essential if you want to continue or improve your success.

dends throughout the year. There are many talented business and photography speakers. Personally, I enjoy listening to the marketing- and businesspeople. You might even want to consider attending marketing and business programs that are not put on by photographers. After all, good marketing is essential to your success.

Networking with associations outside of photography is also a great way to meet new people and cultivate your business. Also, working with your fellow vendors such as catering halls and florists can be beneficial. To make the most of these relationships, consider this tip: If you get to the catering hall before the wedding guests, take some photographs of the entire hall, the table settings, decorations, etc. Print some 8 x 10-inch images and give them to the caterer in a couple of weeks. Now he has some professional photographs to show new clients and, in all probability, he will remember who gave him the pictures. Do the same with the florist. Take some close-ups of the flowers at both the reception and the church and send them to the florist. It's all the little things you do that will ensure your success.

Your local Rotary, Lions, and Kiwanis clubs are excellent organizations to get involved with, not only for business contacts but just because they do good things for the community. Often, the school superintendent or principal attends meetings at the local service clubs, so this can make for a great networking opportunity. Remember, you are in the image business—both literally and figuratively.

> You might even want to consider attending marketing and business programs.

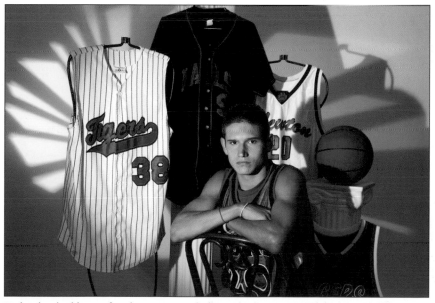

High-school athletes often bring jerseys, balls, and other sports-related props to their sessions. Adding a colored gel behind the subject gives these shots a little extra impact.

11. SUMMING IT ALL UP

■ DOING SOMETHING YOU LOVE

Unfortunately, the world is filled with people who don't like their jobs. There may be a few exceptions to what I'm about to say, but I think most people would agree with the following: anyone who is truly successful at what they do for a living probably loves what they do everyday. When you are doing something you truly enjoy, you naturally will do a better job.

Photography is not an easy business to make a living in. The need to wear so many different hats—creative artist, top-notch marketer, practical businessperson—makes it even more difficult. But if you really enjoy photography and can surround yourself with some really good people, you will more than likely succeed. Be optimistic and listen to positive people. Spend time in the company of people who are where you want to be in life.

When you are doing something you enjoy each day, you will be a much happier person, and your happiness will be very apparent to your clients, employees, family, and friends. I'm not telling you that everyday is a holiday in this business. Just like any other business, you are going to have problems. Many times it not the problems but how you deal with them, though, that defines your success.

The really cool thing about the photography business is that, for the most part, you are around people when they look their very best. They have called you because they want you to create an image of them to share with their family and friends. They have put their trust in you. When they are thrilled with their images and then give you a sizeable order for your talent, it is very rewarding.

> When you are doing something you truly enjoy, you will do a better job.

This stunning black & white image was made even more beautiful with the addition of the digital "handcoloring."

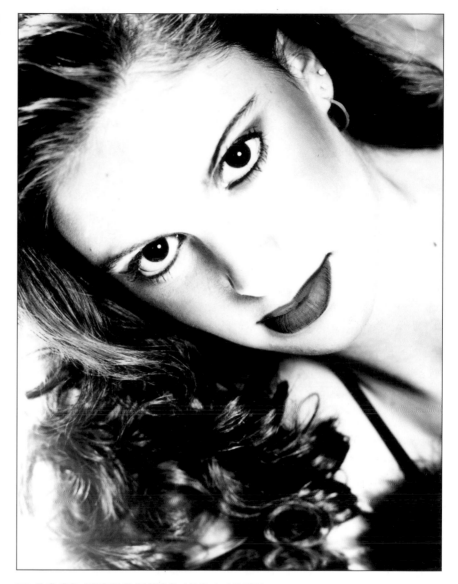

■ GOOD PEOPLE SKILLS ARE A MUST

Good people skills are important in many jobs, but particularly in photography. When a client has called you for an appointment, they are expecting a photograph that they are really going to like. The best photograph of someone is usually one where the subject looks relaxed and natural and has a great expression on his face (remember: ESP—Expression Sells Portraits!). Engaging the client in relaxing conversation about their interests is a great start to a portrait they are going to be happy with. However, the only way that is going to happen in the photography session is through your excellent people skills. This is something I believe is truly a natural talent. I don't think you can really teach someone how to be a good communicator and listener—but if you are naturally comfortable talking with all types of people, you are well on your way to creating images that your clients will love.

◼ IF IT WERE EASY, EVERYONE WOULD BE DOING IT

Okay . . . maybe what I should say is, "If it were easy, everybody who owns a studio would be profitable in photography." Unfortunately, according to the Professional Photographers of America, approximately 30 percent of all studios never make a profit. This doesn't even count all of the part-timers who do not rely on photography for their livelihood. They are happy if they make a few extra bucks on the weekends.

This is not an easy business in which to make a living (we have all heard the phrase "starving artist"). However, there are also studios out there that are doing extremely well, but this takes a lot of work and a lot of time. Rome wasn't built in a day! It takes several years for any kind of business to be successful. It also takes work by someone who recognizes that *success has very little to do with taking beautiful pictures*. If you only remember one piece of information from this book, that's the phrase to keep in mind.

The major reason so many photographers are struggling is that they focus their time and energy exclusively on the photography portion of the business and mostly ignore the business and marketing segments. I have visited studios in my state that have extremely profitable operations and not one single trophy or ribbon from print competition. On the other side of the coin, I know people who have just about every award you can get in photography and have hardly any clients. Please don't misunderstand what I'm trying to say—doing what it takes to win blue ribbons and trophies will definitely make your photography better, but it certainly will *not* guarantee financial success. Awards are a very small piece of the success pie. To your clients, you are only as good as your last portrait session.

You must have a blend of skills if you are going to make a living in photography. Some of the information you need to succeed is found in this text. Be fair with yourself—develop a business plan, work the plan, and plan to work. You cannot do this by yourself. Set both short- and long-term goals and expect some failures along the way. Don't get discouraged, and always learn from your mistakes. Owning a successful photography studio is very rewarding. People come to you because they trust your skills and talents; they don't want to just look *good* in their photographs, they want to look *really good*—and they have called you for the job. Practice your craft, keep a keen eye on business and marketing, surround yourself with excellent employees, and you will be on your way to being successful—in any market!

> To your clients, you are only as good as your last portrait session.

VENDORS

Albums Inc. (albums, frames, folios, etc.)
15900 Foltz Industrial Parkway, Strongsville, Ohio 44149
1-800-662-1000

Blossom Publishing Company (color brochures and cards)
P.O. Box 307, Winona, Minnesota 55987
1-800-583-5370

Capri Albums (albums, folios)
515 South Fulton Avenue, Mount Vernon, New York 10550-2093
1-800-666-6653

Elyria Color Service (color lab)
517 Lake Avenue, Elyria, Ohio 44035
E-mail: ElyriaColorService@alltel.net
1-800-829-4034

Flash Point Studios (voice talent for phone systems)
www.flashpointstudios.com
1-877-352-7478

Hal Mar Printing (all printed materials except color brochure)
155 North Street N.W., Warren, Ohio 44483
1-330-399-5034

Response Mail (large marketing mailing envelopes)
4517 George Road, Tampa, Florida 33634
1-800-795-2773

INDEX

B

Business skills, 47–58, 59–70
 cash flow, 56
 delegating tasks, 55–56
 employees, 53–54
 overhead, reducing, 56
 pricing, 48–52, 69
 sales techniques, 59–70
 "sizzle," importance of, 58
 suppliers, 54–55

C

Cash flow, 56
Children's portraits, 62
 sales techniques, 62
Clients, identifying prospective, 12–14
Competition, evaluating, 16
Curb appeal, 13–14

E

Education, continuing, 38–39
Employees, hiring, 53–54
Eyes, lighting, 25, 30

F

Family portraits, 101–3, 118–19
 basic goals, 102
 church directory companies, 102–3

Family portraits, cont'd
 consultations, 102
 marketing, 118–19

G

Goals, setting, 11–12

H

Hair, lighting, 26–28

L

Lens selection, 36–37
Lighting, outdoor, 29–30
 flash, 30
 gobos, 30
 reflectors, 19–30
 shadowed eyes, 30
Lighting, studio, 19–28
 background light, 25–28
 fill light, 19–20
 hair light, 25–28
 main light, 20–25

M

Management, studio, 47–58
Marketing, 104–19
 direct mail, 105–6
 family portraits, 118–19

Marketing, cont'd
 mall displays, 106–7
 planning, 104–5
 senior portraits, 107–14
 sports league photography, 117–18
 wedding photography, 115–17
 yellow pages, 107
Mentor, finding a, 39

N
Networking, 120–21

O
Overhead, reducing, 56

P
Posing, 30–35
 full-length portraits, 35
 head-and-shoulders portraits, 30–33
 overweight subjects, 35–36
 three-quarter-length portraits, 34–35
Practice, importance of, 37–38
Prices, setting, 48–52, 69
Product photography, 103
Psychology of a portrait session, 40–46
 atmosphere, importance of, 46
 creating initial interest, 40–44
 listening, importance of, 44
 people skills, improving, 45
 questions, asking, 44

S
Sales techniques, 59–70
 children's portraits, 62
 closing the sale, 69–70
 presentations, 69
 pricing policies, setting, 69
 senior portraits, 59–61
 setting the mood, 64–69
 wedding photography, 61–62

Senior portraits, 59–61, 74–81, 107–14
 customer service, 79–80
 keys to success, 74–79
 marketing, 107–14
 orders, delivering, 81
 orders, placing, 81
 proofs, 80–81
 sales techniques, 59–61
 session fees, 78
Sports league photography, 91–93, 117–18
 marketing, 117–18
Studio, appearance of, 12–15

T
Telephone skills, 12–13, 71–73, 95–96
 answering machine, 71
 etiquette, 71–72
 professionalism, 73

W
Wedding photography, 61–62, 94–101, 115–17
 clients, types of, 94–95
 marketing, 115–17
 pricing, 101
 sales techniques, 61–62
 telephone skills, 95–96
 wedding day, 97–100

Y
Yearbook photography, 81–91
 contracts, 89–91
 dances, 85–88
 clubs, 84–85
 sports, 82–84